THE PHOTOGRAPHY HANDBOOK

THE
PHOTOGRAPHY
HANDBOOK

Sue Hillyard

Consultant: Jack Jackson FRPS

NEW
HOLLAND

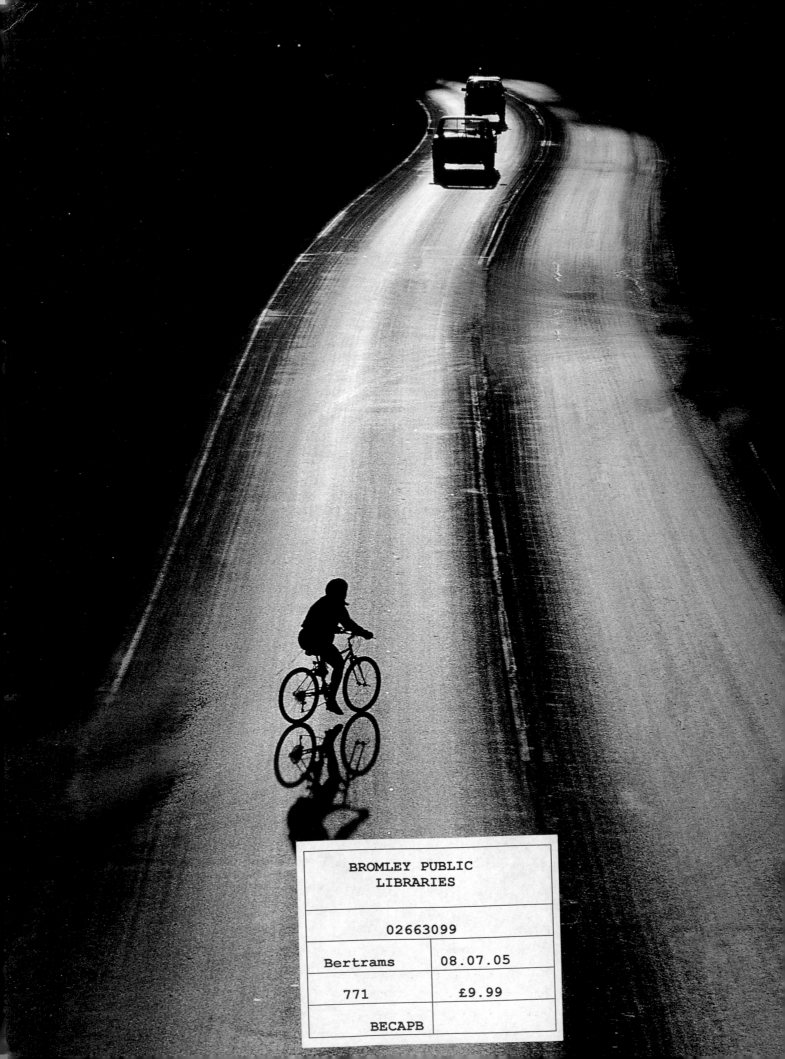

First published in 2003 by New Holland Publishers
London • Cape Town • Sydney • Auckland
www.newhollandpublishers.com

86 Edgware Road	80 McKenzie Street
London	Cape Town
W2 2EA	8001
United Kingdom	South Africa
14 Aquatic Drive	218 Lake Road
Frenchs Forest	Northcote
NSW 2086	Auckland
Australia	New Zealand

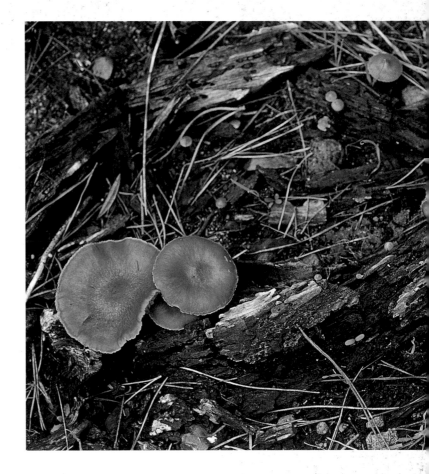

ISBN 1 84330 259 4 (HB) ISBN 1 84330 260 8 (PB)

Reproduction by Hirt & Carter (Cape) Pty Ltd
Printed and bound in Singapore by Tien Wah Press

10 9 8 7 6 5 4 3 2 1

PUBLISHER	Mariëlle Renssen
PUBLISHING MANAGER	Claudia dos Santos
MANAGING EDITOR	Simon Pooley
COMMISSIONING EDITOR	Ingrid Corbett
MANAGING ART EDITOR	Richard MacArthur
EDITOR	Anna Tanneberger
DESIGNER	Geraldine Cupido
COVER DESIGN	Geraldine Cupido
PICTURE RESEARCHER	Karla Kik
ILLUSTRATOR	Steven Felmore
PRODUCTION	Myrna Collins
PROOFREADER	Liezel Brown
INDEXER	Liezel Brown
CONSULTANT	Jack Jackson FRPS

ABOVE: Forest detail. Photographers need keen powers of observation.
Look around all the time – there is a potential image everywhere.
OPPOSITE: Snowmass Road, Colorado. Photography is, simply, working with light.
Always see light as something more than a source of illumination for your pictures.

CONTENTS

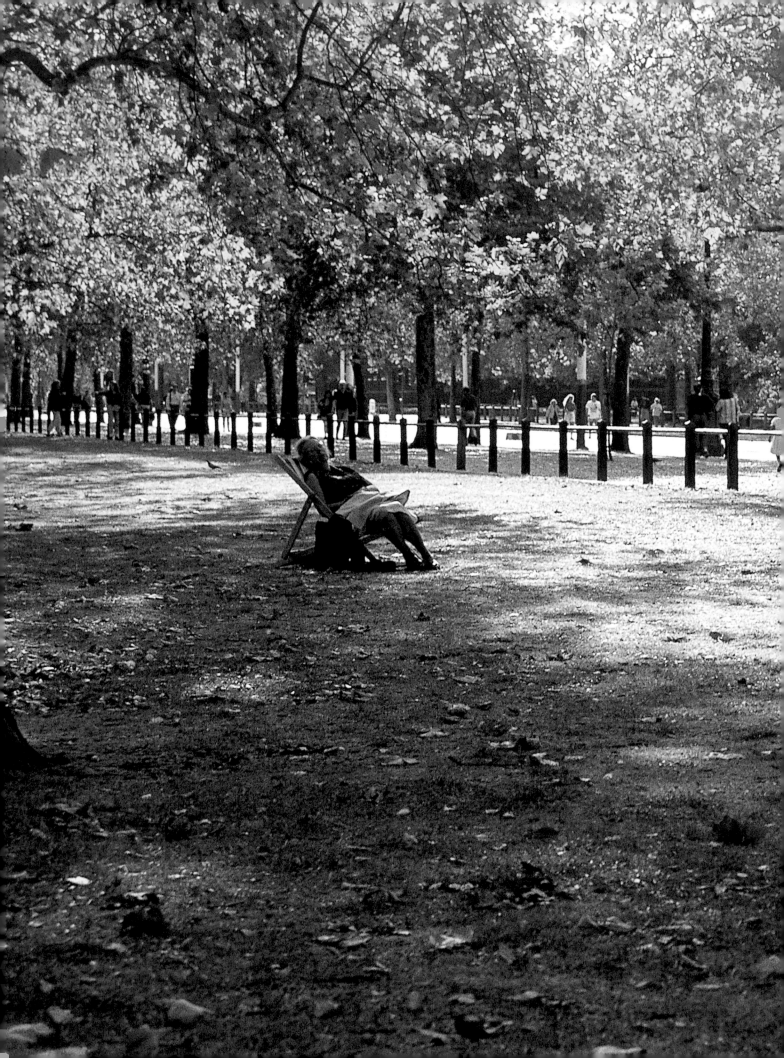

INTRODUCTION

Photography is a language that transcends all boundaries and empowers its practitioner with the ability to communicate visually.

Three components are required to make a picture: light, a camera and sensitive material (film, light-sensitive paper and the electronic equivalent – the Charge Coupled Device of a digital camera). But the photographer also needs a sense of aesthetic to combine these successfully.

The aim of this handbook is to guide you through the maze known as photographic theory. A series of practical assignments will help you understand how to put this theory into practice and create memorable images.

For the beginner there is much to remember, including the smallest detail. Forgetting one small element of the process can nullify the best creative work, even when all other elements are in place. A great deal of the theory of photography is about establishing the discipline of the routine, whether it be the initial exposure of the film or the final processing.

A beginner should eliminate as many of the variables as possible until the process is familiar, before experimenting with different films, filters, developers, etc. Familiarity with the basics will enable you to assess the results of these experiments and to learn from them.

With a firm grasp of the basics, you will keep on learning – even experienced professionals will always find something new to try. Visual research will also develop your skills: by looking at the work of great photographers to see how they deal with the technique, the light, the subject matter and, finally, to assess how these contribute to the communication value of the photograph.

Photography will also heighten and sharpen your sense of observation – you will be seeing pictures all the time – so never travel without your camera.

With the advent of digital cameras, scanning and digital manipulation software, many people believe that silver-based photography will soon be obsolete. However, while digital photography is an exciting path to explore, the same basics need to be learned.

ABOVE: Always carry your camera – you never know when a picture opportunity will arise. This photograph was taken at the Rialto Bridge market in Venice, Italy, when the photographer's eye was caught by the vibrant colour, soft light and an intriguing woman.

It is best to start with simple equipment. A camera with a manual exposure mode will give you control over variables with which you need to experiment to acquire an understanding of how they affect the final picture. Later on you can add to your equipment – other lenses and attachments, etc. Photography is an expensive activity, so budget your spending, take advantage of good deals but beware of cheap or outdated material. If possible, form a group of working photographers, learn together, assess one another's work and create a support structure. Don't be fooled into thinking you need state-of-the-art equipment for good results. It is not the equipment – it is the vision of the photographer that matters.

How to use this book

This handbook was designed to establish an individual learning path. As your knowledge grows, so does your creativity.

Photographic theory is a means to an end. To get the pictures you want, you need to understand the theory, how to use it in practice, its value within the process and then to test this new knowledge by going out to shoot pictures with that theory in mind.

We begin in black and white and then move on to colour. The last chapter explains how to set up a black-and-white darkroom and how to process and print. If you intend doing a great deal of work, this will be the cheaper alternative. If this is not for you, all the practical work could be done using colour, with your film processed in a commercial laboratory.

Keep a log or diary of your shoots with details of the film you used and the various settings, so that you can recreate a desired effect at a later date.

When a word is in **bold** text, it indicates that there is a definition of the word in the glossary at the end of the book. Troubleshooting sections, relating to the preceding subject matter, will enable you to assess what went wrong or, preferably, to understand what can go wrong and avoid making the usual mistakes.

To understand photography you need to know how to 'read' pictures, and to know what makes a photograph 'good' or successful.

Once you have shot off a film or disk – how do you know which is the best picture?

Once you know and understand the criteria, you become more confident and successful in your picturemaking. So, your starting point will be: how to assess photographs.

ABOVE: Warm autumn light enhances the delicate flowering heather in the mountain landscape.

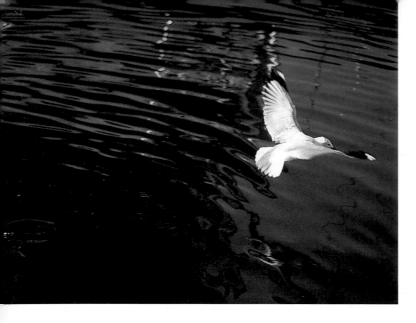

ASSESSING PHOTOGRAPHS

The success of any venture should be measured against the original intention. So you need to establish why you shoot a photograph in the first place before you can decide whether a picture has achieved its purpose.

Some of the reasons for shooting photographs are:

- for pleasure
- to illustrate text
- for documentary purposes
- to make art
- to sell something
- as a reminder of a personal event

All these represent the function of the photograph. Often the function can dictate your technical approach to a photograph. If you are shooting a wedding, you'll need to show the emotion of the occasion. You could use the 'documentary' style: move in close with a wide-angle lens to show the happy couple and the effect they have on those around them (see below). To shoot an athlete competing in the high jump, you will need a good vantage point from a distance and use a telephoto lens just as the bar is cleared – capturing the action – with no distracting background.

The technical criteria by which photographs can be assessed are the following:

- Is the focus good? Most pictures must have good focus to enable them to communicate their content. There are, however, exceptions to this rule.

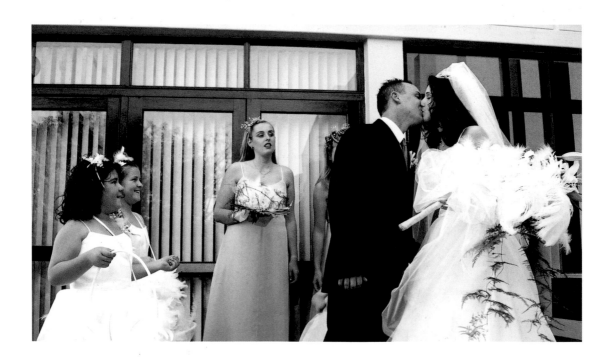

ABOVE: A wedding is a happy occasion for all. As the groom kisses the bride, the little bridesmaids show their obvious delight, while the bride's sister looks on wistfully.

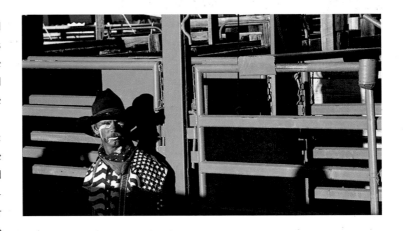

• Has the photographer used camera technique effectively? This refers to the use of the appropriate aperture setting, shutter speed and the choice of lens to achieve the desired effect.

Examples here are effects such as: maximum focus within the picture space using depth of field (determined by the size of the aperture); highlighting the subject with selective focus; or using the shutter either to freeze action or to show the movement of fast-moving subjects.

• Are the elements within the photograph arranged to convey whatever the photograph needs to communicate?

For some photographers, composition is almost instinctive. They move around the subject efficiently, creating an image with the best angle of view and one in which the elements, or objects in the picture, work together perfectly.

• Does the photograph have content or communication value? A photograph can be technically perfect, but insignificant because it lacks meaning. If the subject has beauty or is powerful, the photographer needs to demonstrate this to the viewer. We read images by noting their function, technical and compositional aspects and responding to their content.

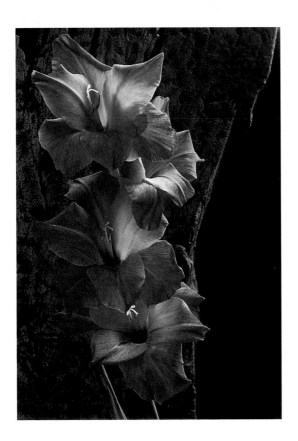

Visual Literacy

In primary school we learned to read words, now we need to learn to read pictures. Page through your daily newspaper and keep one photograph each day that has good communication value in your opinion, and one that is bad. Keep these pictures in an Image Bank file — making a note of your personal response to it below each one.

At the end of the week, look through all your assessments and establish if later analysis of your selected photographs has changed the way you first saw these pictures.

TOP: The rodeo clown is dwarfed by the cattle pens, yet the small red area dominates the overall green (see complementary colours, p101) affirming his importance in the ring.
ABOVE: The beauty of flowers is their cycle of growth. I used studio light to enhance the fragility of the petals, the softness of the colour and the beauty of the form.

CAMERAS

There are four basic types of camera, classified according to their view-finding system – how the image is seen by the camera. These systems can be basic or complex, affecting not only how the image is viewed, but also the design and function of each type of camera. (Names of cameras given here may differ slightly in different countries.)

Classification of cameras

1. Direct vision (includes compact or point-and-shoot)

This camera type has a simple lens in the view-finding system for seeing and composing the image, and a separate lens for photography. The illustration shows how these two aspects are separated. The advantage of this type of camera is that the image is always clearly seen – even in low light. The disadvantage is that it causes parallax error – the image through the viewfinder differs from that of the photographic lens. This could result in an unfortunate crop – like cutting off your subject's head. The closer you are to the subject the worse this error becomes. Some direct vision cameras have a frame indicator in the viewfinder, which indicates the boundaries of the image in the lens. The photographer composes the picture in this frame.

Direct vision or compact

Examples of a compact: Olympus Stylus Epic; Canon Sure Shot 76 Zoom; Pentax IQ Zoom 80S QD.

These are all-in-one cameras with automatic exposure and a fixed focus lens. They do not have interchangeable lenses, though some have a zoom facility. They have no manual controls other than shutter release, and no depth-of-field check or parallax error compensation. They are DX coded (see p22), have built-in flash with red-eye reduction and the facility for date and time of picture. Example of a direct vision: Leica M6 TTL.

Top-of-the-range direct vision cameras like the Leica are more sophisticated than compacts. They have a rangefinder system, which enables the photographer to focus the image. They have interchangeable lenses of the highest optical quality. They are rugged, have parallax compensation, a very quiet shutter release system and through-the-lens metering (TTL).

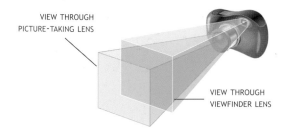

VIEW THROUGH PICTURE-TAKING LENS

VIEW THROUGH VIEWFINDER LENS

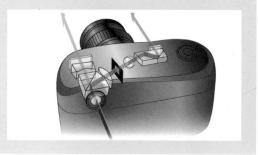

ABOVE LEFT: The diagram illustrates the error of parallax.
ABOVE RIGHT: The coupled rangefinder system.

2. Twin lens reflex

This is a bulky 'old-fashioned' type of camera that, like the direct vision, has a double-lens system – one for viewing and the other for photography.

Unlike the direct vision camera, however, its lenses are identical and are attached to the camera body by means of a bellows. They also suffer from parallax error, which can be eliminated by using the frame indicators.

The image they produce in the viewfinder is laterally inverted (left and right reversed in the viewfinder.)

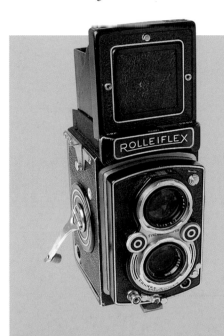

Twin lens reflex

Examples: Rolleiflex; Mamiya C 330
This type of camera is still used by wedding and portrait photographers, as well as students of photography who need to work in medium format at a reasonable price. The advantage of this type is the larger format film, giving better print quality than 35mm. Interchangeable lenses are available for some models, but limited. Disadvantages are parallax error, bulky camera body and the image is seen laterally inverted, which makes panning and action photography difficult.

3. Single lens reflex (SLR)

This type of camera has only one system for viewfinding and shooting. Therefore, what you see through the viewfinder is what you get in the resulting image. The image is diverted from the lens with a mirror, to pass through a pentaprism and onto the viewfinder eyepiece, thus showing the image the right way round.

Single lens reflex (SLR)

Examples: Nikon N90s; Canon EOS
The most widely used type of camera, SLRs come in various format sizes and have the greatest range of lenses and accessories of all types. They are available in fully manual, fully automatic, manual/automatic exposure models using through-the-lens (TTL) metering. They can be attached to microscopes and telescopes. They can be adapted for use as underwater cameras and can be attached to the helmets of parachutists or paragliders. They have been used in outer space. There are digital SLR cameras like the Nikon D1H or D1X.

There are a number of SLRs that take the 120/220-format film size, for example the Hasselblad, Mamiya or Bronica. These differ from 35mm SLRs in that they have interchangeable film backs. This makes it possible to change from colour to black-and-white film or digital without having to rewind the film first. Some models have the shutter inside the lens, eliminating flash synchronization problems. The 120/220-format film increases the quality of the image (see table for range of 120/220 formats p18). Some have TTL metering, while others require hand-held meters.

ABOVE LEFT: In this Rolleiflex the upper lens is for viewfinding and the lower is for photography.
ABOVE RIGHT: This modern SLR has an automatic film-wind facility, DX code reading system (see p22), pop-up flash and a variable exposure-mode facility.

4. Technical, or view cameras

These cameras are of simple construction. The viewfinding screen forms the back of the camera. The front panel, including the lens, is attached to the back by means of a bellows, which forms the camera body. The image produced is laterally and vertically inverted. Photographers who frequently use these cameras become accustomed to an upside-down, laterally inverted image, which then no longer affects the way they see the picture. In the technical camera the lens runs on a double track, which folds out as the camera is opened. View cameras, also known as monorail cameras, are focused by changing the distance between lens and focal plane on this rail to the extent allowed by the bellows.

Technical, or view cameras

Examples: Sinar; Linhof; Toyo
These cameras are used only by professional photographers for studio, architectural or industrial work, portraiture and landscape photography. They use sheet film loaded into film backs. The front and rear components can swing, tilt, or shift in relation to one another, which facilitates control of depth of field (see p72) and converging verticals. They are cumbersome and require a 'set-up' time, but the large film ensures results of an extremely high quality. They also allow the photographer to construct a camera to suit the circumstances and requirements of the shoot. The camera is simply converted to digital by changing the film back to a digital one.

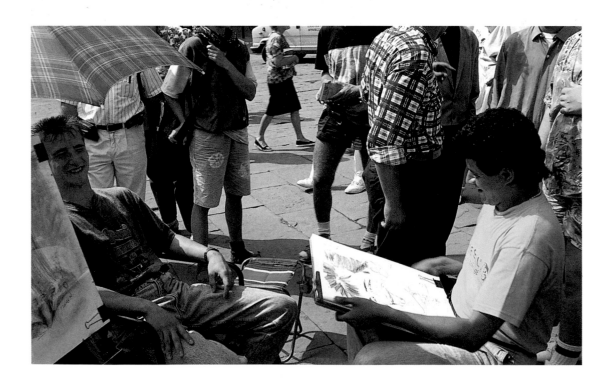

TOP: A view, or monorail, camera with tripod head attachment. A tripod is essential with this camera.
ABOVE: This Florentine artist was captured with a Nikon SLR, its 35–70mm lens set on 35mm wide-angle.

Other types of camera

Panoramic cameras

Example: Hasselblad X Pan.

Similar in construction to direct vision cameras, they use 120/220 roll film to make images of 6x9cm (2¼x3½ in) or 6x12cm (2¼x4½ in). They are used in landscape photography and have wide-angle lenses as standard.

Instant cameras

Example: Polaroid 600

These are specially designed units that process and make a one-off print on site after photography. Some medium-format SLRs and view cameras have polaroid backs, which enable the photographer to check the lighting before shooting with conventional film. With the advent of digital cameras and the rising cost of polaroid film, this type of camera has lost its popularity.

Underwater cameras

Example: Sea & Sea MX 5

This direct vision camera is specially designed for underwater photography. There are also waterproof housings which can be used to convert a land camera for underwater use (see Underwater Photo Handbook ISBN: 1 853686 641 7).

Disposable cameras

Example: Kodak Fun Gold panoramic and underwater cameras. These single-use cameras are cheap and produce remarkably good images for their negative size and plastic lens. They are of direct vision design, and they usually have built-in flash, fixed focal-length lens, fixed focus and automatic exposure.

TOP: A Seychellois seascape with remarkable quality taken with a cheap panoramic camera.
ABOVE: This interesting view of the plants in my garden pond was taken with a disposable underwater camera.

Format

Camera type is often selected for the format (size and shape) of the film that it uses. The most important factor determining choice of format is the effect it will have on the image quality when enlarged. The larger the original format, the greater will be the detail visible in the final magnification. In digital cameras the format will depend on the size of the CCD/CMOS and the number of pixels in its array. The image in a 300x450 CMOS is horizontal in the 1:1.5 ratio, similar to a 35mm film.

Film format	Film delivery	Camera type
APS (multiformat) Advanced Photo System	Cassette	Direct Vision Single Lens Reflex
35mm film size 24x36mm (1x1½ in)	Cassette	Direct Vision Single Lens Reflex
*120/220	Roll	SLR (Medium format) Twin Lens Reflex
Sheet film	Individual sheets (used in film backs)	Technical / View Cameras

* 120/220 gives several formats: 6x4.5cm (2¼x1¾ in), 6x6cm (2¼x2¼ in), 6x7cm (2¼x2¾ in), 6x9cm (2¼x3½ in).

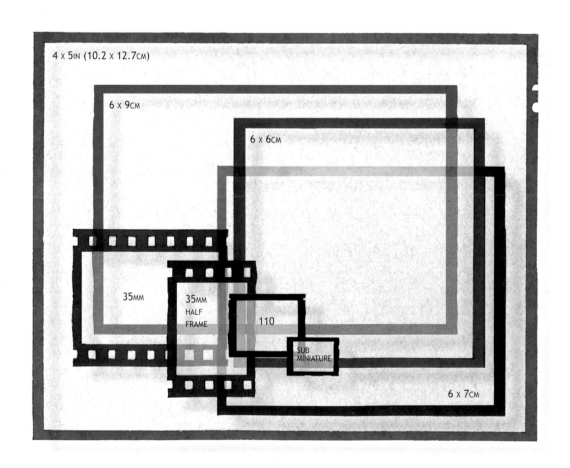

4 x 5IN (10.2 x 12.7CM)

6 x 9CM

6 x 6CM

35MM

35MM HALF FRAME

110

SUB MINIATURE

6 x 7CM

ABOVE: A scale diagram indicating the differing film format sizes. When comparing a 35mm film with a 4x5in one, it is easier to understand how the film size affects quality.

Camera selection

- Decide on your level of interest — this will determine how much you may be prepared to spend.
- Decide on the type of camera you need for your purposes and special interests.
- Do not let yourself be bullied into purchasing expensive state-of-the-art equipment. Start simple, add on later.
- If you are buying second hand, do so from a reputable dealer who will give you some form of guarantee.

- Once you have made your choice, ask questions — and if questions occur to you later, go back and ask them too. Good retailers should have your interests at heart. It is important to form a good relationship with your camera dealer and process laboratory from the beginning — they are part of your support structure. It makes good business sense to use the same supplier regularly, and they should consider giving you good deals.

ABOVE: Picture-making is about catching the image at the right time — the decisive moment. Without the woman and her dog this image would have lacked incident. See p103

Camera controls

Open the instruction manual to the camera identification page. This should help you identify the main features and controls. You will have to shoot a few films before you will feel comfortable with the process.

The camera's anatomy

1. The viewfinder is where the image is seen and composed.
2. The lens receives the light reflected from the subject and refracts it (see p56) to form an image on the focal plane across which the film is stretched or the CCD lies. The distance from the centre of the lens to the focal plane is known as the focal length (see glossary). This distance is used to describe the lens. There are three broad categories: standard (normal) lenses; short-focus (wide-angle) lenses; and long-focus (telephoto) lenses.
3. The focal plane is at the back of the camera, where the image is formed and where the film is positioned or the CCD lies.
4. The focusing system is the mechanism by which the lens is moved to bring the image into focus on the focal plane.
5. Aperture or f-stop. The aperture ring controls the amount of light allowed to enter during exposure of the film, by changing the size of the aperture opening.

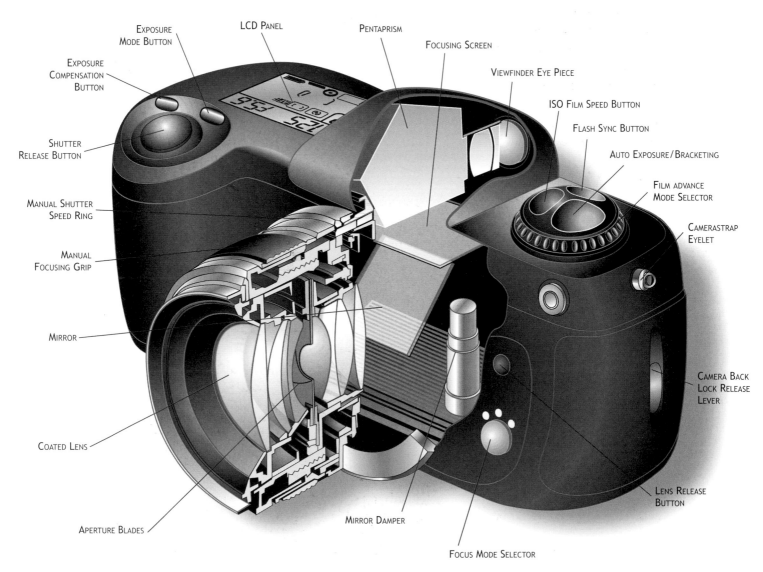

ABOVE: A cut-away diagram of an archetypal single lens reflex camera. This type of camera would have either a pop-up flash or a hot-shoe for a flash unit (not shown).

6. The shutter speed setting controls the time, in fractions of a second, that the shutter remains open when the shutter-release button is pressed. The shutter in a 35mm SLR camera is situated at the back of the camera just in front of the focal plane and is the mechanism that controls the amount of time for which the film is exposed.

Later chapters will deal in more depth with lenses, exposure methods and camera technique, but from the start it is important to see the photographic process as a sequence of interrelated events. If you forget one aspect or mix up the sequence, you will get a different result – every decision has a consequence, which is not always predictable.

Loading film

Most modern SLR cameras have a motorized loading facility (see right).

If, however, your camera type is not auto-loading, ensure that the film is securely slotted into the take-up spool – fire the shutter and wind on with the camera back open so that you can satisfy yourself that the film is secured and winding. Now close the camera back and shoot another frame.

Check that the top of the take-up spool turns as you wind. If not, carefully turn the winder back until you feel resistance.

Remember that in some cameras the film counter may continue to count even when there is no film in the camera.

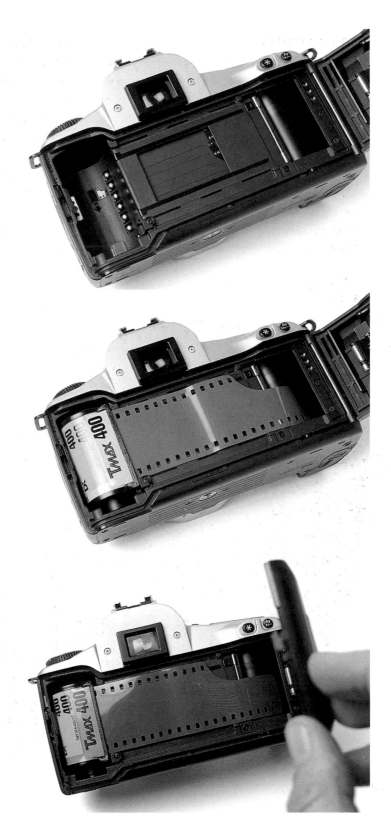

TOP: Looking at the focal plane of a modern SLR, showing the DX code reader in the left recess.
MIDDLE: Cassette inserted, with film stretched across the focal plane to the take-up spool.
ABOVE: Secured, with sprockets lined up, some cameras will wind on automatically when closed.

Setting film speed

Film speed is a number or rating system that indicates a film's sensitivity to light, indicated as ISO. Fast films have higher numbers, e.g. 400 ISO, and can be used in low lighting conditions. Slow films, e.g. 100 ISO, can be used under good daylight conditions.

If your camera has the DX facility, the film speed will be set automatically on the metering system. The DX system enables the camera to read the film's ISO through a series of metallic patterns on the cassette. You can override the DX facility if you want to re-rate film (see p48). If your camera does not have the DX system, you will have to set the film speed manually.

Setting film speed on your camera, or light meter if you are using a hand-held meter, adjusts the exposure reading for the sensitivity of the film.

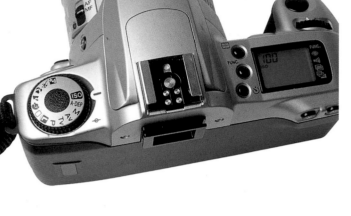

Taking a meter reading

The next step is learning to evaluate the light. Photography is about working with light – being aware of how it changes in different conditions and with different sources; and using it to create moods.

Getting the reading right is essential to the process. Once you have set the film speed, the two major controls are aperture (f-stop) and shutter speed.

The aperture is like the iris of the eye, which controls the amount of light that passes through by changing its size.

f2 f2.8 f4 f5.6 f8 f11 f16 f22

Widest aperture allows Smallest aperture allows

maximum amount of light minimum amount of light

Featured above is the basic range of apertures found on most lenses. Some of the long focal-length lenses can open as wide as f2.8 or f3.5, while some short focal-length lenses can go down as small as f32. You will also find that the LCD light-meter readings in some modern SLRs will give you stops in between these. It is important to understand the relationship between these 'stops' of exposure.

f5.6 f8 f11

f5.6 allows twice the amount of light as f8,
which allows twice the amount of light as f11

Aperture controls the amount of light (light intensity) – so if you widen the aperture from f8 to f5.6, you are letting more light through the aperture and giving your film double the amount of light it was getting at f8. If, however, you close the aperture down by one stop from f8 to f11, you reduce the amount of light by half.

Therefore, each stop by which you open up will double the amount of light and each stop you close down will halve the amount of light passing through.

Shutters control the duration of exposure i.e. for how long the film is exposed to light. Shutter speeds are measured in fractions of a second from eight seconds through to $\frac{1}{2000}$th of a second or faster. There are two types of shutter design – focal plane and leaf type. In most 35mm SLRs the shutter is of the focal plane type.

TOP: The Pentax MZ 6 is a fine example of a modern autofocus single-lens reflex camera.

This consists of two blinds that move vertically or horizontally across the focal plane at the back of the camera. The problem with this shutter design is that it has to be synchronized at or below a set maximum shutter speed when using flash (see flash photography p33).

View cameras or medium format SLR cameras have leaf shutters inside the lens itself. This type can synchronize with the flash at any shutter speed.

The basic range of shutter speeds used in most SLRs is as follows:

| 1 | ½ | ¼ | ⅛ | 1/15 | 1/30 | 1/60 | 1/125 | 1/250 | 1/500 | 1/1000 | 1/2000 |

Slow **Fast**

The shutter speed setting is the timing device for exposure, which is measured in fractions of a second, e.g. ¼, 1/60th or 1/1000th of a second and, as with apertures, each increment is double that of the previous setting.

The aperture and shutter speed work together to control the amount of light passing through to the film by adjusting the size of the opening and the time that it is left open.

When you take a light-meter reading, you are evaluating the light at that time, with that film speed and for that subject matter. The shutter speed and aperture combination given by the light meter is for that particular circumstance only. If you change one of these variables (e.g. move your camera's position in relation to the light source), the above combination will no longer be valid and you will have to re-evaluate the light.

In the next chapter different methods of light evaluation will be discussed in detail, but for now remember the basic exposure equation: Exposure is the intensity of the light for a duration of time (according to film speed set), where aperture controls the intensity and shutter the time.

Whatever the numbers are in each reading, it is their combination that is important.

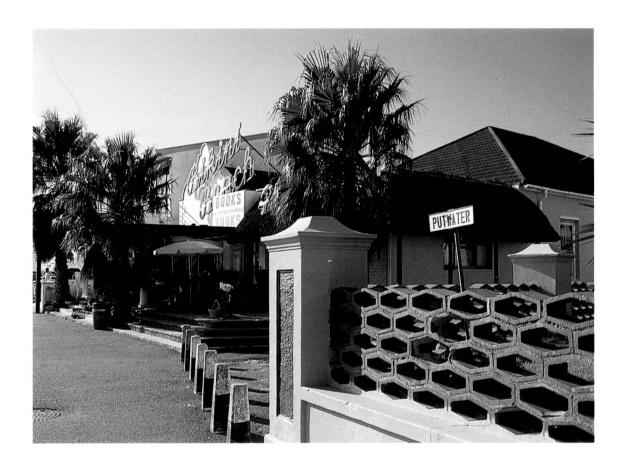

ABOVE: Contrasty light has desaturated the colour rendition of this image. Beginners should avoid contrasty light, especially at noon, until they know the camera and sensitive material better.

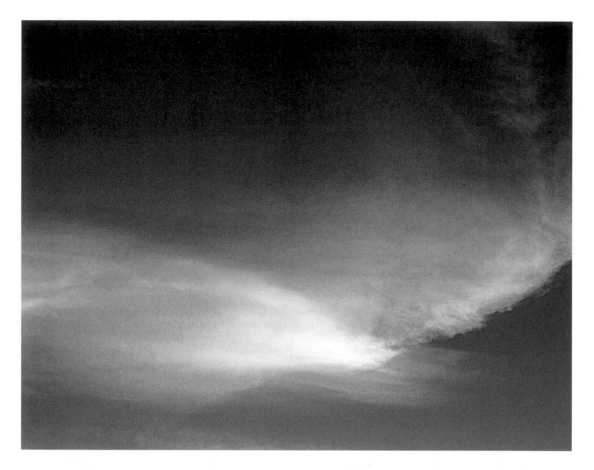

Shooting

The first decision to make is the shutter speed or aperture with which to begin. Assess the photographic situation. Look at the light. Where is it coming from and what is it doing to the subject? If, for instance, you are shooting at 10:00 in the morning during the summer months: the sun is shining and there is good light around you and illuminating your subject, you will need to start with a fairly quick shutter speed, such as $\frac{1}{250}$, and then work the aperture from there. This means that when you evaluate the light, you will be working with the aperture ring or dial. There are many different ways of displaying the reading from the light meter. It could be a dial similar to a speedometer inside the viewfinder, or flashing red or green LEDs, or a needle that moves between a plus and minus scale. How to read the light meter is one of the most important questions to ask the dealer when you buy the camera. It will also be described in the manual. If your camera has an automatic/manual function, set it on manual. Working on manual gives you control over the results, which is particularly important in learning to understand the different results from different settings.

Removing film

Once the film is at its end, and you are using a 35mm camera, you need to wind it back into the cassette before removing it from the camera body. Some SLRs have an automatic film rewind system, which starts immediately the film reaches its end. Others require you to do it manually in one of two ways. Some cameras have a pair of rewind indicators that you need to depress simultaneously. Others have a button marked R on the base plate of the camera body which, when depressed, releases the take-up spool, enabling the photographer to rewind the film manually.

ABOVE: Simple is best. When starting out, try to keep your compositions simple – they are easier to control and always look good.

Accessories

You will be tempted to buy all sorts of gadgets to go with your new camera. The best advice is to start simple and add on later. Consider only what is absolutely necessary for you at this stage. Here are a few guidelines:

- Tripod. If your budget extends to the purchase of a good quality, sturdy tripod – then go ahead. Tripods ensure that your camera is kept still during long exposure times. If you find working with a tripod restrictive, consider buying a monopod – this is like a tripod, but with only one leg. It gives you something to lean on without the restriction of three legs.
- Filters. Single lens reflex cameras have the widest range of filters available. Their use is explained in greater detail in the chapter on light and lenses (see p63), but it is prudent to buy a skylight filter for every lens you own. The function of this particular filter is to reduce ultraviolet radiation and to penetrate haze. The other advantage is that it keeps the outer element of the lens clean and free of dust and fingerprints. Attempting to remove these can sometimes damage the coating of the lens. It is much cheaper to replace a filter than a whole lens.
- Camera bags. Your needs will depend on the type of photography you intend doing and there is a wide variety to choose from, such as soft, padded-over-the-shoulder or back-pack types, rigid suitcase, etc.

Camera care

Keep your camera clean and free of dust and fingerprints. Dust on lenses or filters result in unsharp images and will affect the quality of your work. Dust inside the camera body can cause scratches on the film, which will render the film unusable. A blower brush is an important item in the care of your camera and lenses – use it to dislodge dust from the lens surface or inside the camera. Take great care when using cloth or lens tissue. If the dust is stuck onto the surface, you could damage the lens coating by scratching the surface when trying to dislodge it.

The camera body itself can be cleaned with a soft cloth while the terminals and input sockets should be cleaned with a soft brush or canned compressed air. Check the batteries regularly and keep the contacts clean. If a battery has leaked acid, clean the chamber with a cotton bud. If you are concerned that the residue has damaged the contact points, clean with a rubber eraser and take it to a camera repair technician.

If you live in a climate with high humidity, pack some silica gel sachets into your airtight camera case, and do not forget to dry them in a warm place occasionally, so that they remain effective.

Troubleshooting: Loading film

1. Your processed film is clear.
- The film did not wind onto the take-up spool, therefore, although the numbers were counting up, the film was not being exposed.
2. First negative on film is very dense (black) and thereafter the film is clear.
- The film only wound on to frame one, thereafter, despite the numbers counting up, you continued to expose only the first frame. This error occurred because the film tension across the focal plane was slack. Sometimes sprockets are torn during loading and the same frame will also be exposed repeatedly.
3. Film is black.
- The film has been exposed to light. This occurs when the camera back is opened before the film is rewound into the cassette.

Setting film speed

If you do not have a DX system and find that you have forgotten to set the correct film speed while shooting a film, do not make a change at this point – it is too late. Rather make a note of the speed you are using and when you hand the film in for processing, inform the laboratory of your mistake; they will compensate for this when processing the film.

Digital photography

Digital photography has revolutionized the world of image making. Like conventional silver-based film photography, digital cameras capture their images on a light-sensitive surface – in this case the sensor is either a Charge Coupled Device (CCD) or a Complementary Metal Oxide Semiconductor (CMOS). These are rectangular grids made up of light-sensitive picture elements known as pixels, which generate an electrical charge proportional to the amount of light that they receive. This voltage is then processed by an analogue-to-digital converter into digital data (binary code) and is stored onto either internal memory or memory cards, which in turn can be either printed directly or 'processed' by a computer.

Once downloaded onto a computer, the image can be manipulated, improved or enhanced to suit the photographer's vision, and is then stored on the computer's hard drive, CD-ROMs, Zip disks or 3.5-inch disks. Files are stored in a variety of file formats, e.g. uncompressed as **TIFF**s (Tagged Image File Format) or compressed as **JPEG**s (Joint Photographic Experts Group), which reduces the file size by 8:1 or 10:1. Printing is via a laser, ink-jet or dye sublimation printer.

If you are using the silver-based (analogue) system, you can also work on your image with computer imaging software by digitizing your negatives, prints or transparencies via a scanner. Working with digital imagery requires a different mind-set than that of analogue.

Camera types

As with analogue models, there is a range of digital cameras available – again the choice depends on your budget and the intended use of the images. To determine what your needs are before buying a digital camera, consider the following factors:

- **Affordability**. The maximum you are prepared to pay. In the low-cost end of the market, the quality delivered by analogue cameras far surpasses that of digital.
- **Long-term savings**. Will the money saved by the use of a digital system override the initial investment? The no-processing-costs claim is not quite true. Unless you are working entirely with electronic transmission, you still have to have the images printed or buy a printer and special paper to print them yourself.
- **Time saving.** Is time so critical that you cannot wait for the processing, printing or scanning of conventional, silver-based film?
- **Digital quality.** Can your newly purchased digital camera deliver the quality in terms of resolution, colour and depth that you need?

Camera options

You need to consider the camera options as well as pixel capability. Megapixel (million-pixel) cameras don't necessarily mean maximum quality – if the camera options are limited, so are you.

- Does the camera offer more than one shooting resolution?
- LCD (Liquid Crystal Display) or TFT (Thin Film Transistor)? Sometimes called Active Matrix LCD, TFT is the sharpest form of LCD monitor screen. You need to decide whether you need the instant replay of these screens or whether you are able to wait until you can download the image onto a personal computer.
- Camera controls – does the camera in your price range offer a choice of aperture or capture speed selection?
- Scanning times. What is your intended use? Some digital cameras suffer from 'shutter-lag time', which makes action photography difficult.
- Internal memory. How many images can you take and at what resolution before you need to download them to make room for more?
- External memory. This refers to interchangeable cards or other memory devices to facilitate your photography.

Point and shoot compacts (aim-and-blame)

These are as user-friendly as their analogue counterparts and offer maximum automation – exposure, autofocus, fixed focal-length lens, flash control, image review and transfer. They tend to produce low-resolution images that would be acceptable for e-mail attachments and small prints only.

Megapixel compacts

The low-resolution result of point-and-shoot cameras has been improved by the new generation of megapixel compacts. They give resolutions of over one million pixels; and in some cameras up to 6 million pixels. However, their options are as limited as that of other point-and-shoots.

Single lens reflex

These cameras have the same shooting control as conventional film-based SLRs and their resolution capabilities are from 3 to 11.1 million effective pixels (see resolution below). This quality enables their use in magazine and newspaper photography. They give the photographer the same choices as their analogue equivalents, such as interchangeable lenses and manual exposure capabilities.

Studio cameras

These take the form of digital view cameras (see page 16) or professional camera backs for medium format cameras (see page 15). These cameras offer resolutions that can be as high as film, but at a very high price. Often these are triple-shot – the camera takes three separate exposures through different internal colour filters onto a monochrome sensor. This limits their use to static subjects, such as catalogue work.

Resolution

As in film-based photography, format size dictates the image quality, but in digital photography there are other factors. With most digital cameras the sensor is only two-thirds the size of standard 35mm film. The number of effective pixels that the sensor can use also determines the quality of the image. Most manufacturers quote the number of pixels for a camera as the number of pixels across multiplied by the number of pixels down the sensor. However, not all the pixels are used in the final image. There are various reasons for this. Pixels, like film, do not detect colour, so the light has to go through coloured filters, usually painted onto the pixels. Some manufacturers use interpolation techniques to boost the apparent number of pixels used in recording the final image. The camera does not record an image using the total number of pixels, or even active pixels, because some of the pixels around the edges of the sensor are covered in black dye as the camera's reference for true black. What really matters is to compare cameras by their number of 'effective pixels'.

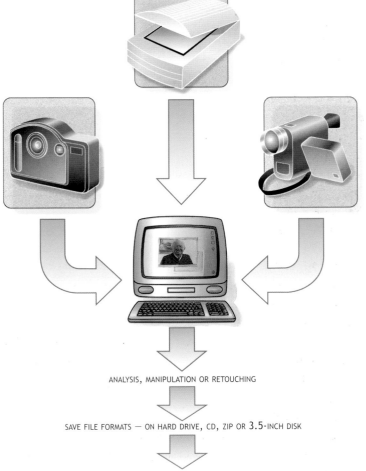

ANALYSIS, MANIPULATION OR RETOUCHING

SAVE FILE FORMATS — ON HARD DRIVE, CD, ZIP OR 3.5-INCH DISK

PRINTED — LASER, INK-JET OR THERMAL FILM. DISTRIBUTED DIGITALLY ON INTERNET OR BY E-MAIL

It is important that you do not confuse pixels with dpi, (dots per inch), which refers to printing specifications relating to output on the printed page.

Memory cards

There are several types of memory cards. What you purchase depends on type of camera and how much memory you require. Examples are Compact Flash, Smart Media and Memory Stick.

The bigger the memory the more images can be stored or the higher the quality of images stored, depending on the intended use of the image – whether for large prints (fewer images of higher quality) or an e-mail image (more images of lower quality), for instance.

Images can be deleted from memory or transferred to other media and the memory card used again.

Some digital cameras offer the option of a sound and video clip, although it rapidly depletes memory space and battery power.

Lenses

The field of view captured by the lens depends on the size of the sensor, just as in analogue cameras the field of view depends on the format size of the film. The 50mm lens is the standard lens for 35mm format film, while in a camera using 120/220 film it is the wide-angle lens. In most digital cameras the sensor imaging area is roughly two-thirds the size of 35mm film format, which means that all the lenses have focal lengths that are different to those normally associated with a 35mm film SLR. Digital cameras are often referred to in terms of 'comparative 35mm value' because most people are familiar with its focal lengths.

Digital and optical zoom

Digital zoom is the electronic enlargement of the image coupled with cropping to simulate 'zooming in' closer with the lens. In reality it is only the pixels that are being enlarged. However, an optical zoom brings the subject closer optically before recording the image on the sensor – thus giving better resolution and a higher quality result.

ABOVE: Photography means to draw with light. Light is spectacular. You need to learn how to use it and get the best from it. This light pattern was created by afternoon light rays passing through a crystal bowl.

Image-capture

Noise, temperature, ISO speeds, white balance

Noise is the visible effect of electronic interference, which usually appears as coloured lines across the image. Two of the major causes are temperature (low is better than high) and ISO sensitivity, where low is also better than high.

Digital cameras have an automatic white-balance setting that enables them to calculate colour balance. Some have preset values for different types of lighting, either by colour temperature on professional models or settings such as Sunny, Cloudy, Incandescent or Fluorescent lighting on amateur models.

Image quality

The resolution to which you set your camera will dictate the quality. This, in turn, depends on the intended use of the image.

Print size

A 15x10cm (6x4in) print requires at least 1.3 megapixels.
An 18x13cm (7x5in) print requires at least 2 megapixels.
A 40x30cm (16x12in) print requires at least 4 megapixels.

The future

Since the advent of digital imaging, prophets of doom have been predicting that it was sounding the death knell of all silver-based photography. To put things in perspective, it is as well to remember that when details of the photographic process were released in Paris on 19 August 1839, the artist Paul Delaroche declared dramatically 'From today painting is dead!' That was over a hundred years ago.

Digital is just another way for photographers and artists to render their work. Both have a place in art and business – it has given us more choices.

ADVANTAGES	DISADVANTAGES
1. Near Instantaneous results	1. Expensive
2. Sophisticated digital SLR models almost rival that of film SLRs.	2. Unless you are using high-end digital cameras the quality of analogue cannot be matched.
3. Process and printing costs are eliminated, although there will be other costs.	3. Auxiliary equipment is needed to produce hard copy (computer, software, printer).
4. Memory cards can be re-used and are not affected by airport security checks — magnetic or X-rays.	4. High battery drain.
5. Long-term benefit to the environment — less toxic chemistry and less exploitation of silver reserves, although disposal of printer toner also poses environmental problems.	5. Only high-end SLRs and studio cameras have interchangeable lenses.
6. Due to the LCD and TFT monitor screens on most cameras, images can be viewed immediately.	6. Difficulty in seeing image on LCD or TFT monitor screens on most cameras in bright ambient light.

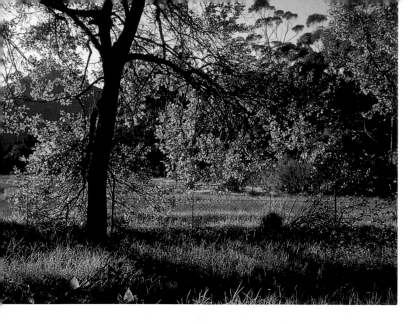

LIGHT

In photography it is essential to understand light and its properties because without light energy there can be no picture. After all, the word photography is derived from the Greek word for light, *phos/phot*, and the Greek word for writing (or drawing), *graphein*. Photography, therefore, means 'drawing a picture with light.'

What is light?

Light is a form of electromagnetic energy that is radiated in straight lines in waveform motion from a source. Our primary source of light is the sun.

Properties of electromagnetic energy

- Radiated in straight lines from a source.
- Travels in waveform motion.
- Classified by wavelength.
- Travels at a speed of 300,000km per second (186,000 miles per second).

The electromagnetic spectrum is the collective name for all types of radiation from very short, high-energy cosmic rays to very long radio waves. The different types of radiation are classified by wavelength, which is the

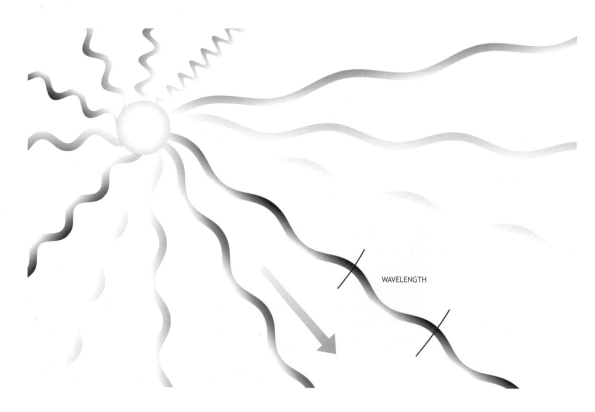

WAVELENGTH

ABOVE: An artist's impression of the properties of electromagnetic energy.

distance between adjacent peaks of a series of periodic waves. These can be as short as one hundred-millionth of a millimetre ($\frac{1}{100,000,000}$mm), while radio waves can be as long as 10km (6 miles). Within this range lies the visible spectrum, or white light.

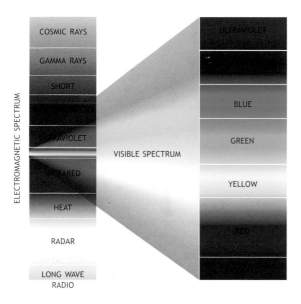

As indicated in the diagram, visible light is made up of a range of wavelengths from violet to red, with violet having the shortest wavelength and red the longest. The unit of measure for wavelengths in the visible light range is the nanometer (10^{-9}m or 32^{-9}ft), with the shortest being violet at 400nm and the longest red at 700nm. On the outer edges of the visible spectrum are ultraviolet and infrared.

White light is composed of all these wavelengths (colours) mixed together. Colour only becomes visible when the wavelength of that particular colour is separated out through a filter or prism, or reflected back from a surface that has absorbed all the other wavelengths. One might almost say that colour is an optical illusion. We are able to see colour because the eye can distinguish between different wavelengths, which the brain interprets as different colours. The sun is the only source of light that radiates energy at the same intensity throughout the spectrum, making it the only true source of white light.

Some sources of light used by photographers, such as candles, incandescent bulbs, tungsten and halogen bulbs, present special characteristics that need to be taken into account. A candle, for instance, emits more yellow and red wavelengths than blue and green. For this reason the image will have a yellow cast when using colour film to photograph a subject under candle light.

Light sources are classified according to their energy emission, which is referred to as colour temperature. Every source of light has a colour temperature rating for which the unit of measure is degrees Kelvin (degrees K). A candle's colour temperature is 1800-2000 degrees K, a standard household incandescent bulb is 2800 degrees K, while that of flash and the noonday sun is 5800 degrees K.

The photographer needs this information when shooting in colour to match the film to the light source or to compensate for it with the appropriate filter; for example, daylight colour film under daylight or flashlight conditions (see the chapters on filters and colour). When using black-and-white film, colour temperature is less important.

Fluorescent light is not generated by heat and doesn't have a colour temperature rating. It has special characteristics different from daylight or tungsten light. The result of shooting under this source of light with colour film is a weird green cast and it is best avoided.

LEFT: The spectrum of electromagnetic energy, of which visible light is a small segment.
CENTRE: Photograph shot with daylight film under incandescent light source.
RIGHT: Photograph shot with daylight film in daylight.

However, whether using colour or black-and-white film, sources with colour temperatures lower than daylight require more exposure and the distance relationship between light source and subject becomes more important.

The Inverse Square Law (ISL) describes how light intensity is affected by the distance of the source from the subject. It states that:

> the intensity of illumination is inversely proportional to the square of the distance from source to subject.

It will be easier to remember that:
when you halve the distance, the subject receives four times the light and when you double the distance the subject receives a quarter of the light.

If, for instance, the light meter has given a reading of $\frac{1}{25}$ at f8 (100 ISO) for a subject 10m (32ft) from the source of light, and the subject then moves 5m (16ft) closer to the source, the same settings would result in overexposure.

At 5m (16ft) the light illuminating the subject would be four times as bright and you would require one quarter of the reflected light passing through the lens.

You can control the amount of light passing through the lens by changing the aperture (f-stop). Each stop halves or doubles the amount of light – depending on whether you are stopping down (less light) or opening up (more light). In our example we need to stop down. F8 to f11 will only halve the amount of light, so we need to stop down again. The correct reading would therefore be: $\frac{1}{25}$ at f16 (100 ISO).

In the above example you could also arrive at the correct reading by changing the shutter speed by two stops. Then you control the amount of light by making the shutter speed faster, allowing less time for light to pass through the lens.

Try another example.

At 10m (32ft) the reading was $\frac{1}{25}$ at f8 (100 ISO).

At 5m (16ft) the shutter would have to be speeded up by two stops, from $\frac{1}{25}$ to $\frac{1}{100}$.

1 $\frac{1}{2}$ $\frac{1}{4}$ $\frac{1}{8}$ $\frac{1}{15}$ $\frac{1}{30}$ $\frac{1}{60}$ $\frac{1}{125}$ $\frac{1}{250}$ $\frac{1}{500}$ $\frac{1}{1000}$ seconds

The new reading is $\frac{1}{100}$ at f8 (100 ISO).

While in practice you would simply take a new reading, it is important to understand the Inverse Square Law because all portable flash exposure calculations are based on it.

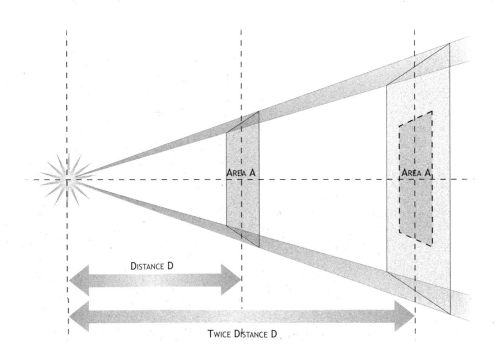

ABOVE: The diagram illustrates the principle of the Inverse Square Law.

Introduction to flash

Working with flash can be difficult to learn because it is an instantaneous light source, the effect of which cannot be evaluated until the results are evident on film. All you can be certain of is that it will produce light and illuminate the subject. However, it does so from the front and not from above as you have become used to, working with the sun as a light source. The effect is unnatural and in most cases it is obvious that flash has been used.

It would be best to consolidate your knowledge and to begin working with flash only once you have acquired some experience and confidence working with natural light.

Flash is a portable light source that generates light by discharging energy through inert Xenon gas via an electronic circuit. The duration of this discharge is typically between $\frac{1}{1000}$th and $\frac{1}{50,000}$th of a second – depending on the size of the capacitor in this circuit.

There are many different methods of flash unit attachment. In some modern SLRs a small flash unit is built into the pentaprism area on top of the camera, which pops up automatically when the lighting level is low.

The flash can be attached to the camera via a hot-shoe fitting, a bracket on top of the camera with a built-in electrical connection to the shutter.

Some cameras have a shoe fitting without synchronization, which has to be achieved via a cord plugged into the camera body PC terminal, which links the flash unit to the shutter release.

Top-of-the-range SLRs like Nikon and Canon have the facility for both methods of connection and can accept a dedicated flash unit. A dedicated unit is connected to the camera's on-board microcomputer via contacts in the hot shoe. This makes it possible for through-the-lens (TTL) exposure evaluations to be taken and for the synchronization speed to be set automatically.

More powerful flash units are attached off-camera. A bracket holds the flash head, while synchronization is achieved through a specialized cord to the PC terminal or an additional hot-shoe attachment.

The choice of flash unit depends on factors such as your budget and the type of photography you will be doing. For instance, would you need a flash to fill in daylight and eliminate shadows – or as a source on its own? You also need to consider your physical strength. Some SLRs are quite bulky; add to that a long focal-length lens (more weight), attach flash unit (more weight) and hold this up at eye-level. If you can't keep steady for $\frac{1}{60}$th of a second, you should consider a lighter unit.

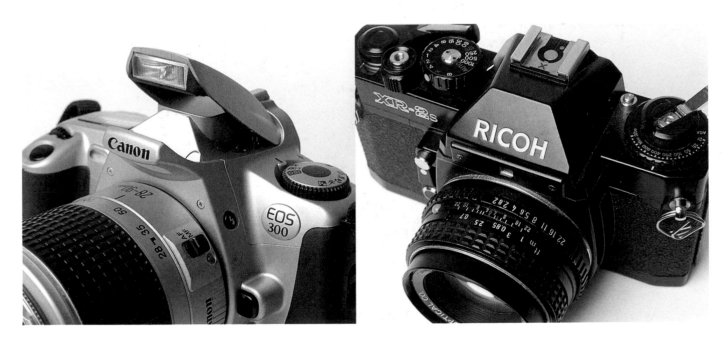

ABOVE LEFT: The pop-up flash unit incorporated into the design of a modern SLR camera.
ABOVE RIGHT: A hot-shoe flash attachment area on an SLR camera.

However, once you've had time to experiment and work with natural light, you would be in a better position to make an informed choice.

Advantages of using flash

- It is portable and easy to use.
- It has the same colour temperature as daylight.
- It is versatile. Some flash heads are adjustable, enabling the photographer to bounce the light off ceilings or walls. Clip-on diffusers can be used to soften the light. The reflector can be adjusted to suit the lens that is being used.
- Flash burst is quick and can be used to freeze fast action.
- Automatic units adjust output levels for distance to subject.
- Sophisticated design can help eliminate the red-eye effect with a preliminary flash that reduces the size of the pupil so that less light is reflected back from the subject's retina. But there is an appreciable delay while this happens and the moment the photographer wanted may be lost.

Disadvantages of using flash

- Limited illumination range due to the principle of the Inverse Square Law – light intensity decreases as distance increases.
- Limited coverage – light also falls off on the edges, resulting in a hot spot in the centre.
- Due to the short duration, the lighting effect cannot be seen by the photographer.
- The lighting effect is flat and flash can cause the unwanted red-eye effect.
- Battery power consumption is heavy.

Choosing a flash unit

Criteria to consider before buying a portable flash unit.
- Power. This is indicated by the unit's guide number – the higher the number the more powerful the flash.
- Portable flash units use battery power. Establish what type of battery it uses before you buy. The choice is

between Nickel Cadmium (Ni-Cd), Nickel Metal Hydride (NiMH) or alkaline; between rechargeable or disposable batteries. Running a flash off non-rechargeable batteries is an expensive option.
- Coverage. Most of the cheaper flash units are designed to cover the angle of view of a standard and wide-angle (35mm) lens. Lateral fall-off will occur for anything wider than 35mm. To compensate for this, some flash units supply a clip-on diffuser to spread the light. There are also flash units that allow the reflector system inside the flash head to adjust for the focal-length lens being used.
- Calculation of exposure. The cost of a flash unit will depend largely on the sophistication of the method used to calculate exposure.

i) Manual. The photographer has to read off the exposure from a dial or chart on the flash body and set it manually. Aperture setting is determined with the formula: f-stop = guide number divided by the distance between flash and subject. The manufacturer gives different guide numbers for different film speeds and whether you measure the distance in metres or feet.

ii) Automatic. This unit can measure the flash to subject distance with a photocell connected to a thyristor circuit, which will terminate the flash light once the film has received the correct amount of light.

Another design feature of automated flash is that the photographer can select the aperture and the flash circuit will adjust the power output accordingly.

iii) Dedicated. These flash units communicate with the camera's on-board microcomputer system to control the flash via contacts on the hot-shoe mount. These units calculate the exposure through the lens and the reading is

TOP: Hot-shoe portable flash unit with auto or manual mode.
ABOVE: Portable flash unit with camera attachment bracket, also with auto or manual mode.

displayed on the viewfinder inside the camera. It is also possible for the photographer to select fill-in flash lighting ratios when working outside and the shadows cast by the sun need to be eliminated. There are units designed to be used with auto-focus cameras, which control the camera's focus in low light.

Exposure

As already explained, light is a form of electromagnetic energy, which changes the light-sensitive crystals with which film is coated. If too much light is allowed through, the crystals on the film are affected to such an extent that not enough differences in density (changed and unchanged areas) will remain to form an image. If not enough light is allowed through, the crystal layers will not be changed enough to form a recognizable image.

The amount of light allowed through the lens onto the film is controlled with the aperture (f-stop) and shutter speed.

To get the correct reading from the light meter, you have to set it for the speed of the film in the camera.

A light meter is a light-sensitive cell that responds to light energy. That response is quick when there is a lot of light and slower in less light. It is consistent in this response.

Manufacturers calibrate these instruments to a reading of light reflected off the mid-point between these two extremes – a zone known as mid-grey (18% reflectance). They are making the assumption that we will always take a reading off mid-grey. In the graph below, Roman numeral I indicates no light (black) and X, maximum light (white).

I	II	III	IV	V	VI	VII	VIII	IX	X
Black				Mid-grey					White

In practice, a reflected-light exposure meter measures the brightnesses of all the objects in its field of view and then gives an exposure recommendation that would render the average of those brightnesses as mid-grey.

If you analyze the lighting situation before reading it, you will be in a better position to interpret the reading. There are various methods of evaluating light and the one you choose will depend on the conditions.

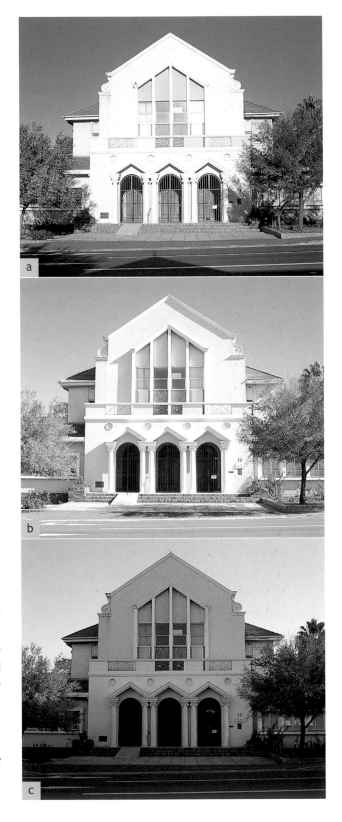

ABOVE: These photographs demonstrate the effect of light on the same subject at different times of the day: (a) at 09:00, (b) at noon, and (c) at 17:00.

Methods of light evaluation

1. An overall reading for an average scene

This method is adequate for most photographic situations. Measure the light that reflects off the subject. In this instance the source will usually be above or behind you, alternatively above or to one side of the subject.

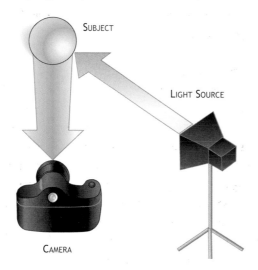

SUBJECT

LIGHT SOURCE

CAMERA

2. Highlight and shadow

At noon the light is bright and shadows will be in sharp contrast. Contrasty light emphasizes the shadows and highlights, and has fewer mid-tones that render detail. Assessing contrast means to assess the range of grey tones a photograph contains. The fewer greys and the more intense the black and white areas, the more contrasty the picture.

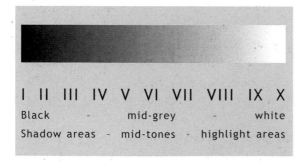

I	II	III	IV	V	VI	VII	VIII	IX	X

Black - mid-grey - white
Shadow areas - mid-tones - highlight areas

Contrasty light (for instance at noon) emphasizes the two extremes. This will affect not only the light meter, but also your choice of film (see p47).

Each step from I through to X represents one stop of exposure. For example, moving up from V to VI gives one stop more exposure (i.e. double the light); and moving down from V to IV gives one stop less exposure (i.e. half the light). With that in mind it is easier to appreciate how much more light energy there is at X than at I.

In very contrasty light one of these areas will be without detail because the exposure range is so vast. It will show up as either all white or all black. Negative film can only deal with a range of seven to eight stops. Slide film has an even smaller range of only five stops.

When you've analyzed the light and decided that it is contrasty, you can use the highlight-and-shadow method of evaluation. This method is also a reflected reading, but you can use your camera like a hand-held light meter by pointing it at the highlight area for a reading and then taking a second reading off a shadow area.

Compare these readings, for example:

Highlight = $^{1}/_{250}$ at f22 (100 ISO)
Shadow = $^{1}/_{250}$ at f5.6 (100 ISO)

f2	2.8	4	5.6	8	11	16	22

Shadow → Highlight

Looking at the range of stops above, there is a four-stop difference between the shadow and highlight areas.

With this method you are calculating the lighting ratio, that is, the difference between the minimum and maximum exposures required. In the above example, the exposure range is too great for the film to render detail in highlight and shadow areas at the same time (see exposure latitude p47). The photographer would have to select the most important area in the photograph and expose for that, knowing that other areas will have little or no detail at all.

If, however, the exposure ratio is three stops or less, and you are using negative material (not slides), you could calculate a reading between the two extremes for an average exposure that should give some detail in most areas.

ABOVE LEFT: The diagram illustrates a reading being taken through the lens of a camera with TTL metering of the light reflected off the object to be photographed.

With less contrast there is more likelihood of detail in both areas (see the chapters on film and printing – burning in p119). The example below illustrates the calculation of an average exposure.

> Highlight = $^1/_{250}$ at f16 (100 ISO)
> Shadow = $^1/_{250}$ at f5.6 (100 ISO)
>
> f2 2.8 4 5.6 8 11 16 22
> Shadow → Highlight

That is a difference of three stops. The average reading would be $^1/_{250}$ at the stop between f8 and f11.

3. Substitution readings

When you can't get close enough to the subject to take a reading and you don't have a spot meter to take a reading at a distance, you can take a substitution reading. You can either use an 18% grey card, obtainable from any photo store, or take a reading off those colours that represent mid-grey in the environment. Green grass under sunlight

is one, anything painted 'pillar box red' is another. This method is equally valid whether you are shooting with black-and-white or colour film. If you use a grey card, make sure that it receives the light in exactly the same manner as your subject. Taking a reading off the palm of your hand is useful when you are photographing people with your own skin tone in street scenes or other fast-changing situations.

4. Incident light reading

In this instance the word 'incident' has the meaning of 'arriving at or striking a surface'. It is preferable to use a hand-held meter like the Sekonic (see below, right) which is designed for the purpose. However, some meters, including some through-the-lens meters, can be adapted by clipping on or sliding over a light-diffusing dome or disk. The diffuser (called an invercone) is shaped to broaden the meter's angle of view to 180°, mixing the light striking it from all angles, as well as any strong directional light at which it is pointed. This enables the photographer to measure the light falling onto the subject, rather than reflecting off it.

A highly reflective surface like a white wall or water could trick the light meter into responding as if there were more light than there is in reality. Incident light readings will eliminate the possibility of this exposure error. Studio photographers use this method to determine light ratios.

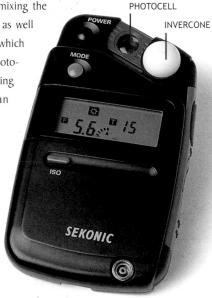

PHOTOCELL

INVERCONE

5. The zone system

The late Ansel Adams designed an exposure evaluation system known as the Zone System. It organizes into one coherent procedure the many decisions that go into exposing, developing and printing a film. This is most useful when you are doing your own processing and printing.

ABOVE LEFT: Using an 18% grey card.
ABOVE RIGHT: A hand-held light meter showing the light cell and invercone for taking incident light readings.

Metering modes

Sophisticated SLRs have, as part of their on-board micro-processor system, a facility for setting different exposure metering modes.

- Manual setting. The photographer sets the aperture and shutter speed after taking a meter reading either through the lens or with a hand-held light meter. Note that all the exposure methods dealt with earlier in this chapter can only be done with your camera set on the manual mode.
- Programme setting. The camera sets an optimum combination for the lighting conditions being evaluated. The photographer has no control over aperture or shutter speed.

- Aperture or shutter priority. This facility enables the photographer to make a decision about the aperture (or shutter speed) required to achieve a desired effect. The camera will then set the shutter speed (or aperture) for the correct exposure.

For example, when you have to work very fast, such as shooting Formula I or Indy Car racing, it would be impossible to take a reading off each fast-moving subject and shoot. With shutter priority you set the speed you want, which in this case will be fast, and the camera adjusts the aperture accordingly.

Through-the-lens (TTL) metering systems

There are three types of TTL measuring systems and they can be dialled in on the camera's LCD read-out screen. Each type is represented by an icon on the LCD. It is important to understand how your camera's light evaluation system works. You need to be confident with the method you are using and what the end result will look like.

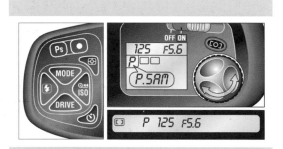

While pressing the MODE button, rotate the command dial. The exposure mode changes in the following sequence:

P Auto Multi-Program → S Shutter-Priority Auto

↑ ↓

M Manual ← A Aperture-Priority Auto

- To activate Vari-Program, use Ps button.
- If your Custom Program has been stored in the camera, P with CP will appear in the LCD between M and P.

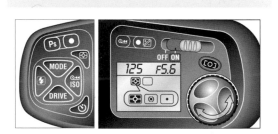

While pressing the metering system button rotate command dial until the desired symbol appears in the LCD panel:

⊞ for Matrix Metering

◉ for Centre-weighted Metering

⊡ for Spot Metering

LEFT: Setting the metering mode on a modern SLR camera.
RIGHT: Setting the TTL metering system.

- **Centre-weighted.** The light is evaluated from all over the area in the viewfinder, but priority is given to the central area. This is based on the premise that most photographers place their subject in the centre of the viewfinder. The image is split into two parts – the centre circle and surrounds. The centre circle influences the exposure slightly more than the surrounding area at a ratio of about 60:40. It will give a good average exposure whether or not your subject is in the centre. However, if you have a lot of sky in the picture, your land area will be underexposed. If your subject is off centre and also unusually dark or light, you won't get a good result.

- **Matrix/evaluative/honeycomb metering.** With this system the light is evaluated over several areas of the image in up to 16 sections. The resulting pattern is compared to data stored in the system's memory. The exposure is then adjusted to give the best result according to the pattern read. In the end the reading is an average one, based on the pattern supplied. Sophisticated systems will allow for brighter areas at the top, where the sky is expected to be. It is, however, still an averaging system and will fail to give a good reading for an unusual composition.

- **Spot.** As with a hand-held spot meter, this type of reading allows the photographer to take a two-degree spot reading from anywhere in the picture area. This makes it possible to take highlight and shadow readings and it allows extremely accurate exposure evaluation.

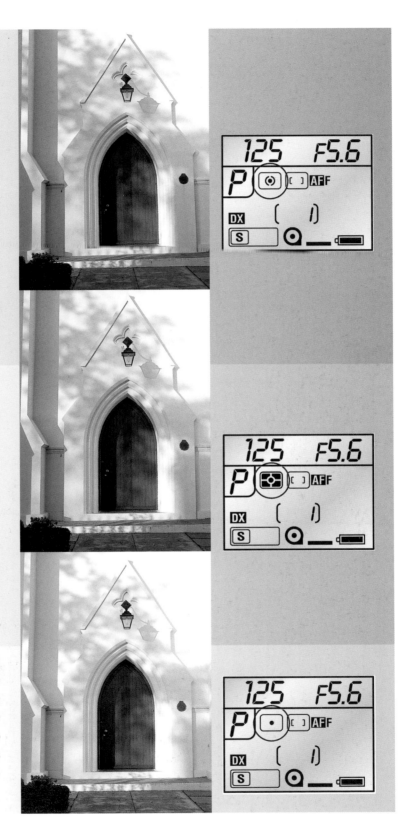

ABOVE: These three photographs illustrate the different results achieved when using the three different TTL metering systems. Due to the lighting ratio at the time of making the photograph, the differences are most noticeable in the shadow areas.

Bracketing

There are some situations in which it is difficult to evaluate the correct exposure. This is particularly important when shooting with colour slide film, which doesn't give much exposure latitude (room for error). You can then give yourself a margin of safety by bracketing.

Starting with the reading obtained with your light meter, you decide whether you are going to keep either the aperture or shutter speed constant. Then you move the other setting up one stop and shoot and then down one stop below the measured reading and shoot.

Let's assume that the light meter indicates a reading of ½₅₀ at f11. If you are using negative material, colour or black and white, your bracketing procedure would be to first shoot at ½₅₀ and f11, then overexpose by one stop, and then another. Return to the original reading and underexpose by one stop and then another.

If you are shooting slides, which allow for less exposure latitude, you should over- and underexpose in half stops for two stops.

It is a good idea to write all this down in a log so that you will know which exposures gave you the best results once the film has been processed (see image below).

Bracketing combinations for a basic reading of ¹/₂₅₀ at f11 using negative material.

Keeping the shutter speed constant
1. ½₅₀ at f11 (from light meter reading)
2. ½₅₀ at f8 (one stop over)
3. ½₅₀ at f5.6 (two stops over)
4. ½₅₀ at f16 (one stop under)
5. ½₅₀ at f22 (two stops under)

Keeping the aperture setting constant
2. ½₂₅ at f11 (one stop over)
3. ½₀ at f11 (two stops over)
4. ½₀₀ at f11 (one stop under)
5. ½₀₀₀ at f11 (two stops under)

Bracketing combinations when using colour transparency film (slides), starting from the same exposure (¹/₂₅₀ at f11)

Keeping the shutter speed constant
1. ½₅₀ at f11 (from light meter reading)
2. ½₅₀ at between f11 and f8 (half stop over)
3. ½₅₀ at f8 (one stop over)
4. ½₅₀ at between f8 and f5.6 (one and a half stops over)
5. ½₅₀ at f5.6 (two stops over)
6. ½₅₀ at between f11 and f16 (half stop under)
7. ½₅₀ at f16 (one stop under)
8. ½₅₀ at between f16 and f22 (one and a half stops under)
9. ½₅₀ at f22 (two stops under)

Keeping the aperture constant
2. (Half stop over) between ½₂₅ and ½₅₀ at f11
3. (One stop over) ½₂₅ at f11
4. (One and a half stops over) between ½₂₅ and ½₀ at f11
5. (Two stops over) ½₀ at f11
6. (Half stop under) between ½₅₀ and ½₀₀ at f11
7. (One stop under) ½₀₀ at f11
8. (One and a half stops under) between ½₀₀₀ and ½₀₀ at f11
9. (Two stops under) ½₀₀₀ at f11

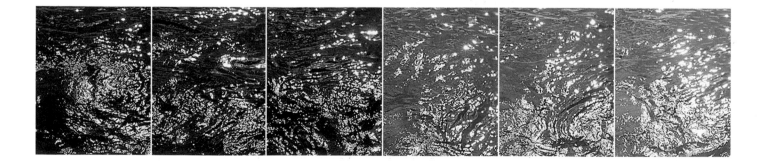

ABOVE: These photographs illustrate the use of bracketing exposure when shooting highly reflective subjects.

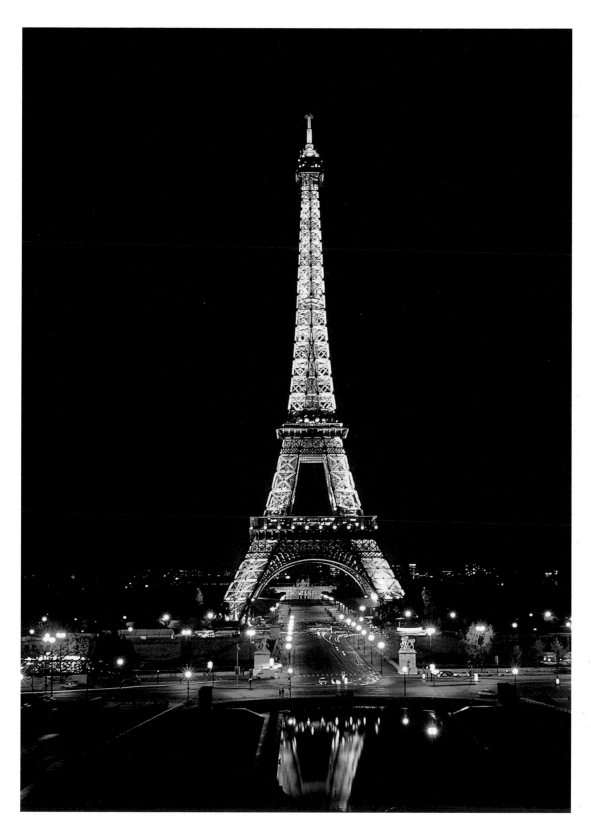

ABOVE: Night photography involves long exposure times. Reciprocity failure (see p 47) occurs under these conditions and despite correct exposure evaluation, the photograph will be underexposed. To compensate for this, bracket exposures on the overexposure side.

Troubleshooting – exposure problems

Underexposed

When photographic film is given too little light, it results in a thin (clear) negative. In the case of a colour transparency (slide) the image will be too dark (see bottom picture).

- The wrong film speed was set on camera/light meter. If you are using 100 ISO film and you set it on 400 ISO, this would result in underexposure.
- The film was incorrectly processed.
- No exposure compensation was made when using a filter or other accessories (see filter factor p63).
- Incorrect method of light evaluation; for example, the light meter may have responded to a highly reflective surface behind the subject and stopped down accordingly or the light behind the subject was too strong and biased the light reading.
- Flash light was underpowered.
- Flash too far from the subject for the f-stop used.
- Battery is old (underpowering the light meter).
- Photographer changed lenses, but failed to set the exposure.

Overexposed

Overexposure occurs when a film is given too much light. This results in a very dark and dense negative. In the case of colour slides the resulting picture is very light, with washed-out colours (desaturated).

- Wrong film speed setting – e.g. exposing a 400 ISO film at 100 ISO would result in a very dark, dense negative.
- Incorrect processing.
- Flash too close to subject for the aperture used.
- Old battery – (underpowering the light meter).
- Photographer failed to set correct aperture when changing lenses.
- If your photographs are constantly overexposed, the fault could be with your camera, rather than with your light evaluation technique. A camera in need of a service may begin showing symptoms such as overexposure because the shutter sticks open or the aperture ring does not stop down.

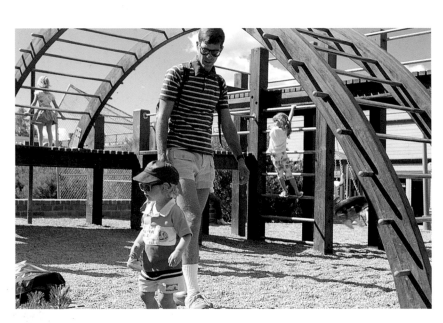

TOP: Overexposure due to incorrect exposure evaluation. The resultant photograph shows the characteristic desaturation of colour.

ABOVE: Underexposure here has resulted in dense colours and lack of detail in shadow areas.

Troubleshooting — flash

- Only part of frame is exposed. Photograph was taken with a camera with a focal plane shutter, and shutter speed was too fast to synchronize with the flash. In the image below, right (c), the flash synchronization speed of the camera used here is $\frac{1}{250}$th second. However, the shutter speed was set to $\frac{1}{1000}$th second to illustrate 'lack of sync.'

 Always check what the synchronization speed is – this is indicated with an x or an arrow on the shutter speed indicator dial.

- A moving subject is partly blurred. The subject was illuminated not only by the flash, but also by the ambient light. This available light rendered the subject movement as blurred, while the part lit with flash created a sharp image. To overcome this, turn up flash power if possible, or wait for the ambient light to diminish before shooting.

- Unwanted reflections. Photograph was shot close to a shiny surface like a window, which reflected back into the photograph. Avoid shooting straight at shiny surfaces. If this is unavoidable, turn the flash head slightly so that it illuminates the subject from an off-camera position.

- Red eye. If your camera does not have the modern red-eye reduction system, do the same as above.

- Unwanted shadows. If there is a dark shadow on the surface behind your subject (a wall), the subject was placed too close to it. Move the subject as far from background walls as possible.

- Wrong subject illuminated. This sometimes happens when you are photographing in a moving crowd. You set up for a particular subject, but just as you shoot, someone walks into the picture and is lit by the flash instead of your intended subject – who is lost in the gloom.

- A portrait taken of a subject illuminated by subdued indoor lighting against a harshly lit background will result in a blown-out background and poor illumination of skin tone. In the image (a) below, the exposure reading was taken off the subject's skin tone. Using a portable flash, you can illuminate the skin tone to reduce the contrast, resulting in an image with visible background detail and good skin tone rendition (b). Flash output was set to dominate the exposure by a half stop and bounced off a white ceiling for softer illumination.

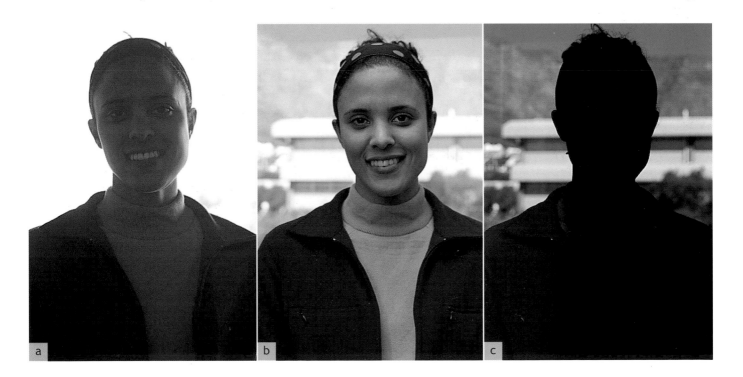

LEFT: Exposure reading taken off the skin tone, without compensating for background light.
CENTRE: Flash used to reduce lighting ratio and render detail in both areas.
RIGHT: Lack of synchronization between focal-plane shutter speed and flash.

PRACTICAL ONE
Light

The practical projects serve as a guide to help you experiment with the theory and techniques that have been discussed in the preceding chapters.

Colour Temperature

Using 100 ISO colour negative film:

1. Shoot a series of photographs of the same scene in the early morning, at noon and in the early evening.
2. Go indoors, and shoot a series of the same subject in candle light and under halogen, fluorescent and incandescent light (ordinary light bulb).
3. Shoot photographs under any other light source you can think of, such as street lamps.

Result

1. By comparing the results you will notice that the quality of light changed. The colour of the light will also have changed. At sunrise and sunset, the colour temperature of light changes, with the result that the longer wavelengths such as yellow and red dominate — thus giving that warm glow.
2. and 3. Evaluate the results achieved under different light sources in terms of colour casts, contrast, and whether any colour cast was detrimental to the image or enhanced it.

File these tests with your evaluations in your log, including all relevant data such as film used, time of shoot and light source.

Inverse Square Law

Place a desk or standard lamp 5m (16ft) from an indoor wall, which has no other source of illumination. Measure the reflected light, taking care not to stand in the path of the light. Write down the aperture, shutter speed and film speed combination.

Move the lamp to a point 2.5m (8ft) from the wall. Measure the light again and compare the readings. There should be a two-stop difference between the first and second readings.

In the reading taken with the lamp closest to the wall, the shutter speed should be faster or the aperture smaller or a combination.

Exposure Evaluation Methods

There are four basic TTL (through the lens) light meter settings on most SLRs — centre-weighted, spot, matrix and program (manual/automatic and aperture/shutter priority). Each of these will produce a different result.

The following are difficult exposure situations.

1. Shadow patterns on a building.
2. Beach portrait.
3. Sea or lake sunset.

Use different evaluation methods (overall reading, highlight-and-shadow, substitution readings and incident light reading) in each situation and decide which will give you the best result.

1. Shadows are dark areas on lighter surfaces. If the building is a light colour, be aware of its reflective properties. Highlight-and-shadow

would be a good method to use here. Make a note of the light ratio and if it is more than four stops, make a decision about which is the more important area in the photograph.

2. For a beach portrait, be aware of the high reflectivity of sand and water. Highlight-and-shadow, grey-card or incident light readings could be used here.

3. A sea or lake sunset presents the problem of strong light reflecting off a highly reflective surface. Highlight-and-shadow or incident readings would be the most accurate, but bracket the exposures to ensure the best result.

Flash Photography

If you have a portable flash and would like to experiment with it, use it in a variety of different situations remembering that the illumination will always be coming from camera position.

Important points to remember
- Set the shutter onto the correct synchronization speed.
- Set the film speed.
- If you are using a manual flash — ascertain the distance between subject and flash, and set the correct aperture for that distance.
- Note that flash intensity fades with distance.
- Be aware of subjects moving into the picture as you shoot.

ABOVE: Evaluating light off a highly reflective surface like this can be problematic, especially when using colour transparency material. Ensure a correct reading by bracketing your exposure.

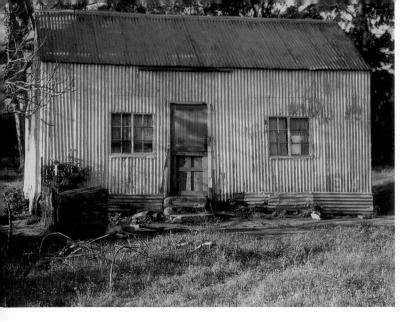

FILM

Photographic film is made up of a light-sensitive substance, consisting of silver halide crystals mixed with gelatine to form an emulsion, which is coated onto a cellulose triacetate base.

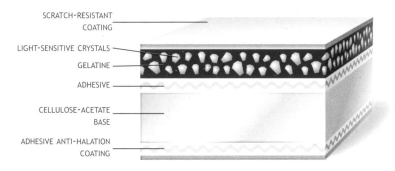

SCRATCH-RESISTANT COATING

LIGHT-SENSITIVE CRYSTALS

GELATINE

ADHESIVE

CELLULOSE-ACETATE BASE

ADHESIVE ANTI-HALATION COATING

Exposure

Camera exposure is controlled by aperture and shutter speed, but the photographer also needs to know what happens when the light strikes the film.

Light energy (in the form of **photons**) energizes the silver halide crystals. This process causes an atom of metallic silver to be formed within the structure of each crystal. This is referred to as the **actinic** power of light – the ability to cause a chemical or physical change in a substance. The actinic power of light during exposure causes the sensitive crystals in a photographic emulsion to form an atom of black metallic silver.

This effect is 'invisible' and the result is known as the **latent image**. It will be revealed once the film is placed in the developer. The developing agent amplifies each atom and renders all exposed crystals to metal silver – with the greatest change in the crystals that were exposed to the most light. The developing process produces the recognizable black **density** on negatives. If you think of this process every time a film is exposed to light – in other words thinking about the image-making process at molecular level – it is easier to understand the results of incorrect exposure. Too little light will mean that not enough atoms of metal silver are formed, which means that there will be insufficient density and therefore underexposure.

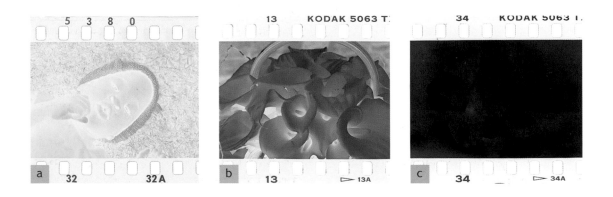

ABOVE: Negative (a) is underexposed (thin) and lacks overall density. Negative (b) has good overall exposure with density ranging from clear film (which prints black) to black (which prints white) and a range of densities between those extremes. Negative (c) is overexposed and irradiation has occurred.

Speed

The speed of a film is the indicator of its sensitivity to light. We can broadly categorize films into slow, medium, fast and ultra fast, each with its own inherent characteristics. The universal speed rating system is ISO (International Standards Organisation). This system combines the numbers of the two other major rating systems as its indicators.

ASA, which is no longer used for film, stands for American Standards Association. Each stop of exposure results in a doubling or halving of the speed, for example:

50	<<<100>>>	200
Slower.		Faster.
One stop more		One stop less
exposure		exposure
needed.		needed.

DIN stands for Deutsche Industrie Norm. It is a European system based on a logarithmic calculation with increments in multiples of 3. For example:

18	<<<21>>>	24
Slower.		Faster.
One stop more		One stop less
exposure		exposure
needed.		needed.

Therefore, by combining these two known systems the ISO ratings for the above examples are indicated as:

50/18 100/21 200/24

It is important to set the film speed immediately after loading the camera. This ensures that your meter will evaluate the light for the correct film speed. If your camera has a DX facility it will do this automatically (see p22). If for some reason your DX reader cannot read the code on the cassette, and you have no manual setting system, the decoder will automatically set the metering system to expose for 100 ISO.

Selection criteria

While speed is an important factor when deciding what film to use, there are other aspects to consider, such as contrast and resolving power.

Contrast refers to the rendition of the tonal range by a black-and-white film. Fast films are said to be contrasty – the relationship between the highlight and shadow areas is clearly defined with mid-tones somewhat compressed in-between. Slow films render a full tonal range that can appear flat or smooth – the tones flow from one to the other.

Resolving power is the ability of an emulsion to render fine detail. Fast films have a lower resolution because of their larger number of grains. They are also more prone to lose definition due to **irradiation**. Slow films have fine grain and excellent resolution.

TYPE ISO	SLOW 25–50	MEDIUM 64–200	FAST 400–800	ULTRAFAST 1600–3200
SPEED	Very low	Low to intermediate	Fast	Very fast
CONTRAST	Very low	Low to intermediate	High	Very high
RESOLVE POWER	Very high (finest detail)	High to intermediate	Low	Very low (less fine detail)

Exposure latitude

This refers to the ability of a film to produce an acceptable image despite over- or underexposure. Negative film allows more latitude than slide film. With negative film your latitude is three stops while slide film gives you only half a stop of latitude on either side of optimum exposure.

Reciprocity failure

Film is designed to be exposed within a range of shutter speeds and apertures. Its variation depends upon film

ABOVE: The table gives the selection criteria for black-and-white film.

speed and the range is often included in the information provided with the film. Reciprocity failure occurs when this range is exceeded with very long or very short exposure times. It is manifested as a loss of film speed (sensitivity) and results in underexposure. (In colour film this will result in a shift in colour.) In these situations it is advisable to bracket your exposures (on the overexposure scale only) for at least three stops. For example, if your reading was indicated as one second at fl6.

Then shoot 2 seconds at fl6 or I second at fll

 4 seconds at fl6 I second at f8

 8 seconds at fl6 I second at f5.6

The same would apply in the (more rare) instances of reciprocity failure due to very short exposure times.

Re-rating film

If you find yourself in a position where your film speed is not fast enough for the lighting conditions, you can re-rate the film to a higher speed (in practice you merely change the film speed on your camera's light meter) and then compensate for this in the developing process. This measure is also known as 'pushing' film. You are, in effect, underexposing and then overdeveloping the film. If you use a processing laboratory, be sure to tell them that the film has been pushed and by how much. Remember that you have to shoot the whole spool at the re-rated speed, because the whole film will be processed accordingly. The visual effects of pushed film are increased grain (an indication of a loss of resolving power) and increased contrast.

Grain

An unsharp image is sometimes mistaken for grain, but grain is not bad in itself. It could be exactly the effect that you want to achieve. As the author of the image, you decide what is desirable – grain is just one of those decisions. In the adjacent table are guidelines on how to create or avoid grain in your photographs.

What film to use

Before deciding on the film to use for a particular shoot, you need to assess the photographic situation so that you select the film with the characteristics – whether for speed, contrast or resolving power – best suited to the situation, and the result you want to achieve.

Selection guidelines

- Slow to medium films: 25 to 200 ISO. The major advantage of using these films is the fine grain. This renders good detail, improved colour saturation or smooth continuous black-and-white tonal range and good quality for enlargement.

TO CREATE GRAIN	TO AVOID GRAIN
Use fast film	Use slow film
Use high energy (b/w) developer	Use fine grain (b/w) developer
Rate at higher speed/ push process	Use medium or large format cameras
Enlarge a selected area of a negative when printing	Minimize the cropping of negatives when printing

ABOVE: This studio portrait was photographed using slow (ISO 50) black-and-white film. The result is grainless, with the contrast enhanced by the lighting.

The lighting needs to be good or you will need a tri-pod – this is not the film to use for action photography in low light. It is best suited to portraiture, studio and still life work, landscape and any situation where you need to reduce the contrast, such as shooting at noon on the beach. Examples of this type of film are: (Kodak) T Max 100 or Plus X Pan 125 ISO; (Ilford) Delta 100 or FP4 125 ISO or Pan F 50 ISO; and (Agfa) Agfapix 100.

- Fast and ultrafast films: 400 – 3200 ISO. Fast films are versatile – they can be used indoors or outdoors in a variety of situations. At sunrise or sunset, their speed enables a workable reading and good results, but in the harsh light around noon they produce very contrasty images. Fast films can be successfully re-rated and can produce effective grain and contrast when the image demands it. They allow the photographer to work with small apertures and fast shutter speeds, which are advantages when shooting action or landscape photo-graphs. They can also be used confidently to capture images under difficult lighting conditions such as music concerts, stage productions or fashion shows. It always makes good sense to carry fast film in your camera bag; it will always help you out many a time in unpredictable lighting situations. Examples are: (Kodak) T Max 400 or Tri X Pan 400 ISO; (Ilford) Delta 400 or HP5 400 ISO; (Agfa) Agfapix 400 ISO.

Other black-and-white films

Most photographic stores will stock these more special-ized films and, if not, should be in a position to order it for you. Alternatively, contact the brand distributor (see Useful Info p122).

- Chromogenic. If you would like to work in black and white, but have no darkroom of your own, shoot with this film and it can be processed at your local one-hour laboratory using the same process as for colour nega-tives. You can choose to have these negatives printed in black and white or in a **sepia tone**. They have great exposure latitude and, unlike conventional film, you can expose individual frames on the same roll at different film speeds and get printable negatives in all cases. These black-and-white films produce a dye image rather than a silver one and they must be developed by the same process as colour negatives. Examples are: (Kodak) T Max 400 CN; (Ilford) XP2 400 ISO.

ABOVE LEFT: This environmental portrait was made using 400 ISO film rated at 800. The quality of the light was soft, which would have given a flat result, but the film was pushed to increase contrast.
ABOVE RIGHT: The dye density of 400 ISO Kodak Chromogenic film gives a softer, almost grainless result.

- Line/orthochromatic. These films are sensitive to blue and green light only, and consequently do not produce a continuous-tone negative. They have extreme contrast and, given appropriate development, produce a result with extreme black and white and minimum mid-tones. They are primarily used when a high contrast result is required, or for the reproduction of text.

- Infrared. Infrared (IR) film is sensitive to the longer wavelengths invisible to us, as well as the spectrum of visible light. When shooting with this black-and-white film it is necessary to use a deep red (e.g. Kodak Wratten # 25) filter to create the desired effect – an interesting graininess and a tonal shift. All living, energy-emitting subjects render higher tonal values than usual. For example, live green plants render near white on IR film, but mid-grey on conventional film.

IR film has no ISO rating because the proportions of visible light and infrared radiations vary from scene to scene. This problem is further compounded by the fact that light meters are insensitive to infrared. This means that you would have to conduct a series of film tests to establish a film speed for your equipment and lighting. Once calculated, you would use this as a basis for all exposures – but you will still have to bracket exposures. The landscape photograph (a) opposite, top, shows the interesting dramatic effect that can be created with IR film. The photograph below it (b) shows the result without the filter.

IR film has applications in scientific, medical and biological photography because it can reveal the heat, or energy, radiating from living subjects, which conventional film cannot. For example, IR film was used during World War II to show the presence of enemy troops beneath camouflage. IR film would show up any areas of dead foliage used for camouflage. Scientifically it can be used to show pressure points, which would develop heat under stress testing. In medical science it can assist surgeons to distinguish between living and dead tissue, for instance when amputating a gangrenous limb.

An example of IR film is Kodak High Speed Infrared. Few laboratories have the facilities to process IR film, so you would have to use your own darkroom.

ABOVE: This photograph was made using Kodak Orthochromatic film and was rated at 10 ISO. The film was developed using black-and-white print developer to give a result with more tonalities than is usual with this film.

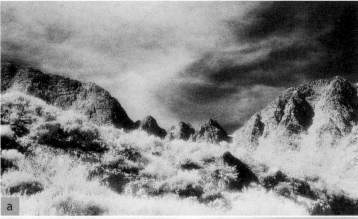

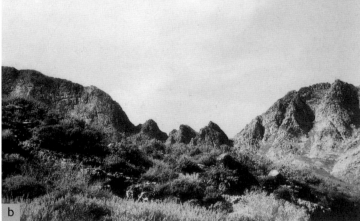

auxiliary focus. The procedure is to focus as normal, take note of the distance and then you set this distance on the red marker.

• Because infrared film is sensitive to heat energy radiation, the speed of IR film is affected by the colour temperature of light (see the guide to establishing IR film-speed rating above). This effect on the speed of the film should be taken into account when testing and later when shooting, so keep a log of all relevant data.

• Infrared film is also available in colour.

• For further reading consult these Kodak publications: M–28 Applied Infrared Photography; N–I Medical Infrared Photography; N–I7 Kodak Infrared Films.

Care and storage of film

• Store in a cool and dry place.

• Keep away from direct sunlight, heaters, radiators, etc.

• If you live in a damp or humid climate, store your film in a sealed plastic bag with silica gel sachets.

• Although it is not strictly necessary, most professionals store their film in the refrigerator. However, ensure that the container has a good seal against moisture and, when removing the film for use, let it reach ambient temperature before loading into your camera.

• Expose and process film before its expiry date.

• Despite assurances to the contrary, airport X-ray scanners can fog film. Special lead-lined carry bags are available, but security personnel are likely to demand that you open it for inspection, or the operator can turn up the intensity of the scanner and fog your film anyway. It is simpler to carry your film in a sealed see-through plastic bag and request a hand inspection.

Guide to establishing IR film-speed rating

This basic guide is based on the use of Kodak High Speed Infrared film.

• Use a # 25 Kodak Wratten filter.

• Under daylight conditions test with ISO rating 50.

• Using photoflood lamps test with ISO rating I25.

• When shooting, bracket at least three stops on either side of the evaluated reading.

Important points when using infrared film

• Always load in absolute darkness.

• Process as soon as possible after exposure.

• Always use the smallest possible aperture. IR wavelengths are longer than those of visible light, which means that the point of focus would not be the same. Most lenses carry a red marker on the distance scale for

ABOVE: These images show the dramatic effect that can be achieved with IR film. The top photograph (a) was taken with filter and (b) without filter.

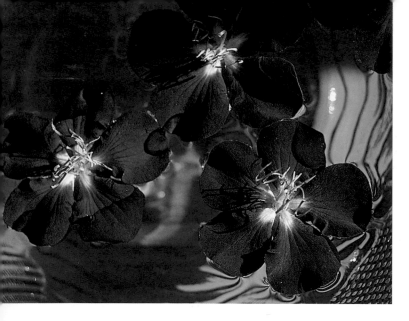

LENSES
AND OPTIC
THEORY

Understanding, not only the properties of light, but also what happens when light meets a surface, is important in the understanding of lenses. In summary, light travels at high speed and is radiated from a source; it travels in straight lines in apparent waveform movement.

Light does not necessarily illuminate the subject surface with the same properties that it had when it left its source. Its characteristics and intensity are changed by factors such as climatic conditions and distance from the subject. Understanding how light can change will help you assess how it can work for you in your photographs. It will also help you with exposure evaluation, lighting technique and composition. Energy cannot be destroyed. Therefore, when light meets the surface of an object and it fails to illuminate that object, it must have been absorbed.

Practical example: place two pieces of cardboard in direct sunlight – a white piece and a black piece. After five minutes of exposure to the sun, touch the cards. The surface of the black card will be hot, but not that of the white card – the light energy was absorbed by the black card, but reflected by the white. In sharp sunlight, just looking at the white card is difficult because of its high reflective quality.

ABOVE: These back-lit clouds create a dramatic atmosphere in this landscape. Consider light as a compositional element and not only as a source of illumination in your photographs.

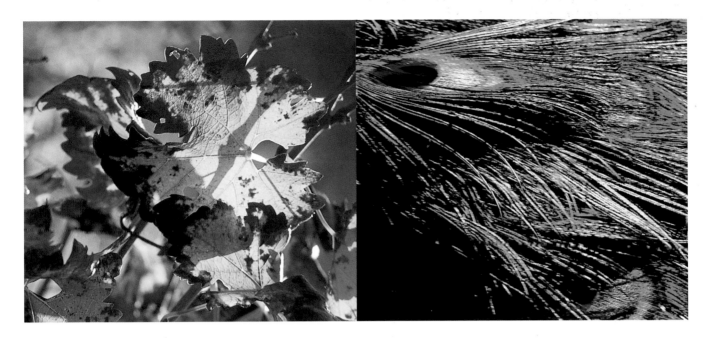

Reflection

Photographers are concerned with two kinds of reflection. Specular reflection (from the Latin word *specere* for 'look', and 'mirror') happens when light energy reflects off a bright or highly polished, smooth surface. Diffuse reflection (from the Latin word *diffusus* for 'spread about') happens when the light energy is scattered by a rough surface.

Incidence is the arrival of a beam of light or particles at a surface. The angle of incidence always equals the angle of reflection. A rough surface, however, is made up of many tiny little surfaces facing in different directions, so that the angle of incidence will be different for each.

Effectively, the light is reflected in many different directions (scattered, or diffused) from the different tiny surfaces that make up a rough surface.

Whether working outdoors, indoors or under studio lights, the photographer frequently uses a reflector board. Its primary function is to fill in the shadow areas to reduce the contrast between the dark and light areas. For a strong fill, use a mirror and for a soft fill, a polystyrene reflector.

With colour film you could use a colour board to bring colour to the area you need to fill. For instance, photographers often use gold reflectors to add warmth to photographs of food in magazines and recipe books.

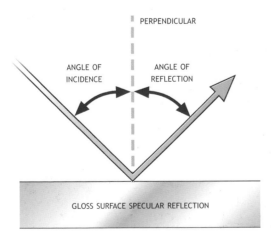

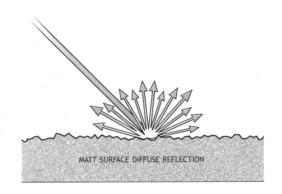

TOP: In the photograph on the left, absorbed light, and on the right, reflected light, do more than simply illuminate the subject; they are integrated into the image.

Transmission

Light has the ability to pass through a transparent or translucent medium, such as glass. The photographer is concerned with four kinds of transmission: direct, diffuse, selective and refractive transmission.

When light strikes the surface of flat, transparent glass at 90 degrees, the only change to the light is a slowing down of its speed through this denser medium. This is direct transmission (see diagram below, left).

When light passes through the clouds in an overcast sky or through translucent glass, the result is a softer light. This is diffuse transmission. Where harsh light would be detrimental to the image you want to create, it can be softened with diffusion (see below, centre).

A filter is a piece of optical glass that absorbs some wavelengths of light and transmits others – that is selective transmission. In the chapter on film, the use of the Wratten # 25 filter was described when shooting with infrared film (see p51). It selectively transmits the red and infrared wavelengths while absorbing the ultraviolet, blue and green wavelengths (see below, right).

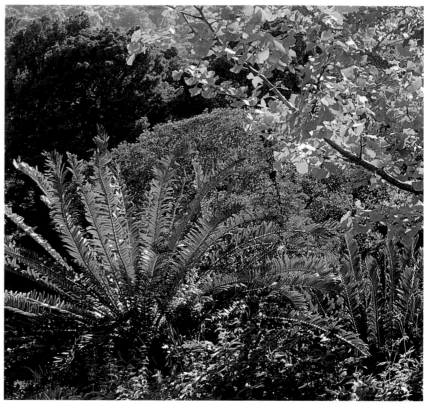

Refraction occurs when a ray of light meets the surface of a transparent medium of different density at an oblique angle, which would be the case when it meets the curved surface of a lens. Due to the fact that light travels in waveform movement and that glass is denser than air, the side of the wavefront which strikes the glass first slows down,

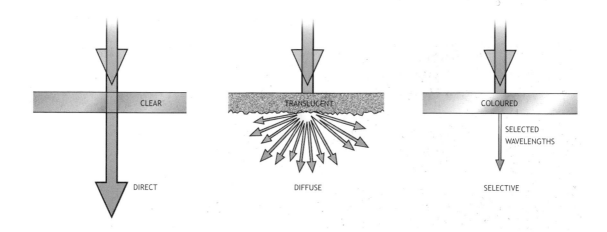

TOP: Light transmitted through the translucent leaves emphasized the different shades of green in this landscape.

ABOVE: The diagrams illustrate direct, diffuse and selective transmission of light.

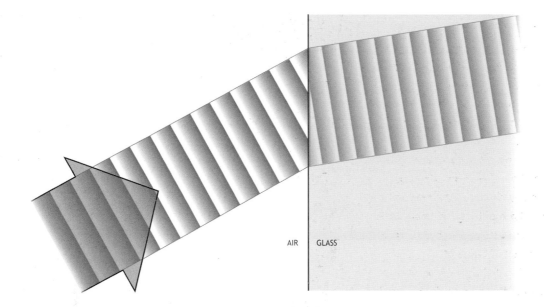

AIR | GLASS

while the other side maintains its original speed of travel until it, too, enters the denser medium. This causes the ray to swing and change its direction of travel (see above).

This change in direction, or refraction, causes the light to come to a point on the focal plane to form the image (see below).

Refraction can also result in the dispersion of light. The visual effect of this is a rainbow. The amount by which an incident wave changes direction when it enters a denser medium at an angle depends on its wavelength – each wavelength having a different **refractive index**. Since each colour has a different wavelength, and will therefore bend by a different amount, glass can disperse white light into its component colours (see right). Rainbows are

beautiful to photograph, but dispersion is a headache for the lens designer. This is the major reason for the use of multiple glass or plastic elements, with differing densities and curvatures, in modern compound lens design.

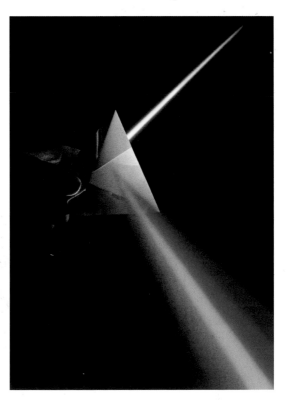

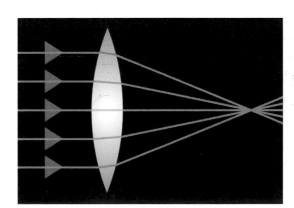

ABOVE RIGHT: A glass prism disperses light into its constituent wavelengths to form a rainbow.

Controlling light

As early as the fourth century, Aristotle used a pinhole as an aid to view a partial eclipse. Later the theory of the pinhole as a controller of light (see diagram below) was used in the manufacture of the **camera obscura**. These were viewing-only cameras because there was no means of preserving the images created by them.

Although the images produced by a home-made pinhole camera are interesting and moody and can be preserved by inserting light-sensitive paper, such cameras cannot be considered working instruments. A pinhole cannot produce sharp images in a short exposure time. Therefore, the need arose to improve camera optics.

The simple lens (see below) with its curved surface collects more light, resulting in a brighter, sharper image than that from a pinhole (see below, left). However, a single lens is likely to cause dispersion; distortion through its inherent **aberrations**; and the resulting image will lack overall sharpness. Therefore lenses had to be designed which use several glass or plastic elements of differing densities and curvatures to eliminate these problems (see compound lens opposite). Aberration is the inability of a lens to render a perfectly sharp image across its entire field. Further elements of a compound lens are then chosen to compensate for these inherent aberrations in each particular element.

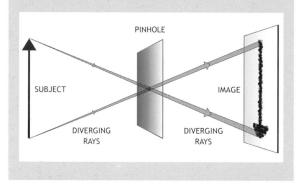

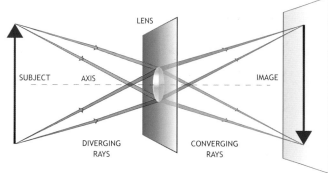

ABOVE: This image of a road sign was made using a coffee tin as a pinhole camera. The negative was made using photographic printing paper, which was then contact-printed onto paper to give a positive image.

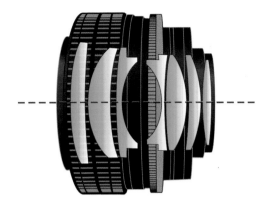

Focal length

Apart from the technical definition (see glossary), focal length could be said to indicate the 'light-bending power' of a lens – in other words, how it affects or manipulates the light that passes through it. The length referred to is the distance between a standard point in the lens to the focal plane, where the film is, when the focus is set at infinity. The longer the focal length, the greater the magnification of the image.

As a beginner, it is important to know (a) the type of lens, (b) its function, and (c) how it affects the image.

Compound lenses

The design of a compound lens is based on two basic glass element shapes. A converging lens brings light to a point. A diverging lens does the opposite – it spreads the light. By using these two basic shapes a lens designer can control the light. Lenses can be designed for many different purposes by using different combinations of elements. Lenses are classified by their **focal length**.

Lens classification for a 35mm SLR

1. Normal or Standard (50mm)
2. Short Focus or Wide Angle (18–35mm)
3. Ultra Wide Angle (8mm)
4. Long Focus or Telephoto (60–300mm)
5. Ultra Telephoto (400mm plus)

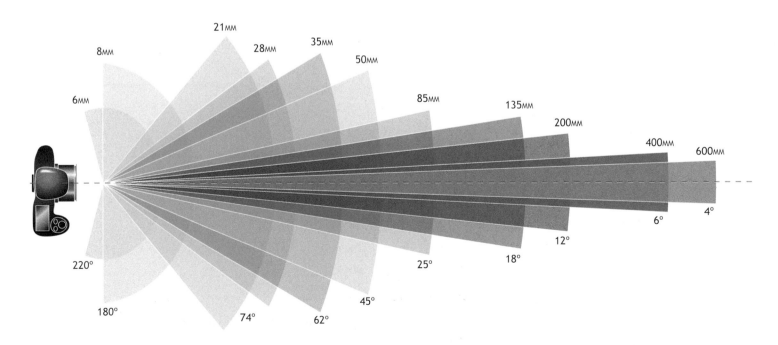

TOP: Cross-section of a compound lens made up of multiple glass or plastic elements of differing densities and curvatures.

ABOVE: A diagram showing the angle of view of a selection of different focal-length lenses.

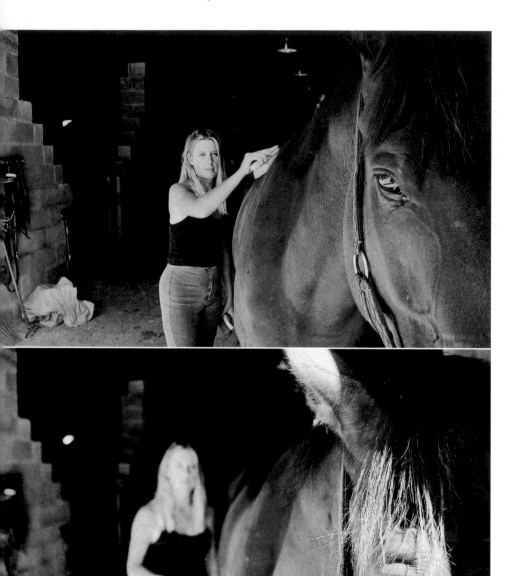

dictate where you stand in relation to the subject, which would ideally be about 3m (10ft). However, if circumstances force you to stand much further away, you would have to use a longer focal length, such as 200–300mm, in order to get the required magnification.

The main factor determining the choice of lens is the relationship between the subject and the background. This will depend on how much background you want to include or how dominant you want the subject to be in the picture.

Focal length determines the magnification (size of the image on the film) and angle of view (how much of the surroundings is included in the picture). The size of the image increases in proportion to the focal length. If the subject remains at the same distance from the lens, the image formed by a 24mm lens will be half as big as that from a 50mm lens.

The relationship between different elements in the composition will be distorted by the longer lens as the distances in front of and behind the subject are foreshortened (concertina effect). The longer the lens the more blurred the background (**selective focus**); the shorter the lens the greater the effect of **depth of field**, and the more pronounced **linear distortion**. These effects are collectively referred to as the **visual impression**, which is the result your choice of lens will have on the photograph.

There are no rules that limit the use of a lens to one particular function. There are basic guidelines to help you make a decision once you have assessed the photographic situation. For example, a portrait (head and shoulders) is usually taken with a telephoto lens with a focal length of around 105mm. This would be a good choice if you can

To summarize the criteria that affect choice of lens, their uses and characteristics have been condensed into table form (see opposite page).

TOP: Shot at f16, focusing on the eye of the horse; the small aperture ensures maximum depth of field.
ABOVE: Shot at f5.6, keeping the focus on the horse's eye; due to the wider aperture, selective focus highlights the horse's head only. These images were taken from the same viewpoint (refer to the size of the rider, ignoring apparent change of position due to movement of the horse's head).

	Short focus (Wide angle)	Normal (Standard)	Long focus (Telephoto)
ANGLE OF VIEW	Maximum. The shorter the focal length, the greater the angle of view.	Normal eye vision.	Minimum. The longer the focal length, the narrower the angle of view.
MAGNIFICATION	None.	Normal eye vision.	Maximum. The longer the focal length, the greater the magnification.
VISUAL IMPRESSION	1. Linear distortion. The wider the lens, the greater the effect. The closer to the subject, the greater the effect. 2. Enhances the effect of depth of field.	Normal eye vision	1. Foreshortening ('concertina effect'). The longer the focal length, the greater the effect. 2. Enhances the effect of selective focus.

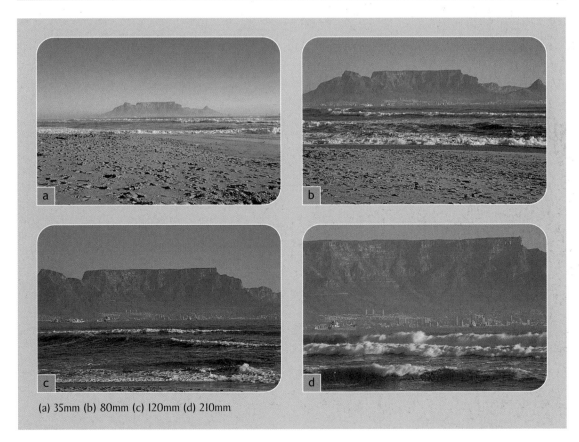

(a) 35mm (b) 80mm (c) 120mm (d) 210mm

ABOVE: This landscape was photographed using a range of focal-length lenses. Note the effect that lens choice has on the relationship between the subject and its background and foreground.

Specialist lenses

These lenses are designed for specific tasks and to facilitate photography in difficult situations.

Zoom lenses

A zoom lens is one of variable focal length – that is several lenses in a single barrel. They ensure quick, immediate photography and are used in photojournalism, child photography, sport and fashion. Their design enables a quick change through a range of focal lengths as described on the lens barrel, e.g. 17–35mm, 35–70mm or 70–210mm.

The focal length is changed by means of a control ring on the lens barrel. There are two types:

- one touch – change of focal length (zooming in or out) and focus are achieved by a single mechanism
- two touch – there are two separate mechanisms with which to achieve change of focal length and focusing

Lenses are rated according to their speed and this is determined by the maximum aperture of the lens.

Macro lenses

Although most lenses allow you to work close up, macro lenses are specially designed to enable the shooting of subjects in extreme close up. They have many applications in science, especially botany and medicine.

When working with a macro lens, precise focusing is essential due to the extreme lack of depth of field. You will always find that the closer you move to the subject, the more selectively focused the image will be.

Mirror lenses

The major drawback of long focal-length lenses (500mm or longer) for sport and wildlife photographers is their weight and bulk. Hence the development of mirror lenses. The use of mirrors in place of some glass elements decreases the physical length of the lens, but increases the barrel width. This makes the lens much lighter and more portable.

A disadvantage of mirror lenses is that they have a fixed aperture of around f8 or f11, which means that, frequently, adjustments for exposure readings have to be done with shutter speed or the use of neutral density filters (see p64) or a combination of both.

ABOVE: These two images show the use of a single zoom lens (35–70mm), set at its two extremes. Note the loss of depth of field in (b), taken with the lens at 70mm.

ABOVE RIGHT: In (c) a standard zoom set to 55mm was used, and in (d) a macro 55mm lens.

Perspective control (pc) lenses

These are usually wide-angle lenses (28 or 35mm) which have a built-in facility for shifting the lens to one side of its central axis. These mimic the **camera movements** of the large format view cameras (see p16), which enable the photographer to shoot pictures of subjects like tall buildings without getting the effect of **converging verticals** or subjects seeming to fall backwards.

Lens attachments for close-up work

Close-up or supplementary lenses are used like filters and are affixed to the end of the lens barrel for the purpose of increasing the focal length of the lens.

Extension tubes or bellows are attached between the lens and camera body and used as macro lens substitutes. While this is convenient, the drawback is that the use of this kind of equipment changes the optical characteristics of the lens design, which will adversely affect the image quality.

Filters

Filters are specially designed optical glass, resin or gelatine attachments which, by means of selective transmission (see p56), change or enhance an aspect of the image. There are many types of filters; some have technical uses, while others have aesthetic applications.

The best advice to beginner photographers is: be disciplined in the use of filters and do not rely on them to achieve the required effect.

Filter factor

A filter selectively transmits light; therefore the intensity of the light will be affected and it is necessary to compensate for this loss of light.

The filter factor indicates how many times the exposure must be multiplied. A factor of two means the exposure must be doubled (the next widest f-stop or the next slowest shutter speed). A factor of four requires four times the exposure (two f-stops wider; or two shutter speeds slower; or one f-stop wider and one shutter speed slower). When using two filters together, the factors are multiplied, not added.

If you are using your camera's TTL meter, take the reading with the filter already attached to the lens. If you are using a hand-held meter, divide the film's ISO rating by the filter factor (ISO 100 ÷ filter factor 2 = 50) and set the film speed on the light meter to the new, calculated rating.

Special purpose filters

- **Skylight/Haze/Ultraviolet.** As described in the chapter on light (see p30), sunlight is a source of white light, including the visible range of 400–700nm. However, the sun also radiates other frequencies, invisible to the human eye, but to which photographic film is sensitive, such as ultraviolet light (UV). On colour film it causes a blue cast, or desaturates the colour of the sky. On black-and-white film it causes a washed-out, white sky.

Skylight, haze or UV filters can be used to absorb these unwanted wavelengths. They can be used with

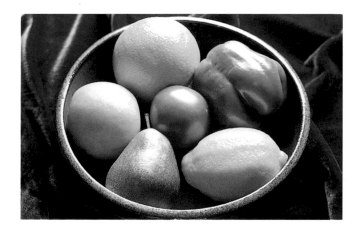
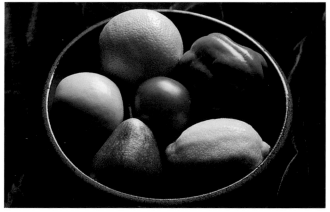

ABOVE: The still life shows the use of a polarizing filter. The image on the left was taken without a filter and the one on the right was taken with a polarizing filter (see following page) set to eliminate most of the reflections. Note the softening effect it has on the image.

both colour and black-and-white films. For this reason most photographers keep these filters on all their lenses at all times. They also serve the purpose of protecting the outer glass element of multi-coated compound lenses from dust or scratches. It is cheaper to replace a filter than a lens.

• Polarizing filters. These are multipurpose filters which reduce or eliminate reflections from shiny surfaces such as glass or water and increase the colour saturation in photographs by removing these reflections. They are particularly popular with landscape photographers because their use ensures a deep blue sky.

There are two types of polarizing filters – linear and circular. A linear filter can be used with most SLR cameras. Circular polarizing filters must be used with autofocus SLRs. A polarizing filter has a rotating mount which allows the photographer to set the amount of filtration required for each individual image. Polarizing filters have a very high filter factor of two to three stops.

• Neutral Density (ND) filters. These filters are used to reduce light intensity without affecting image tonality or colour, i.e. they are used to reduce exposure – so it would defeat the object to compensate for them. The strength of an ND filter is expressed as a decimal, and the factor 0.3 represents one stop, 0.6 represents two stops and 0.9 represents three stops.

Neutral Density filters are used in situations where you need to reduce the amount of light reaching the film – for instance, if you want to use a slow shutter speed or wide aperture (or both) in bright lighting conditions, or if your film speed is too high for these conditions. Then you can reduce the light intensity by using the appropriate ND filter for the number of stops you want to lose.

If the 400 ISO film that you are using is too fast, you can attach a 0.9 ND filter to your lens, which will effectively reduce your film speed to 50 ISO. ND filters are also available in a graduated form.

• Graduated filters. These filters have density at the top half of the filter, and are clear below. They are square in shape and fit into a plastic filter holder that can be attached to the lens barrel. This enables the photographer to lift the filter so that the transition area can be lined up with the horizon. Their function is to create an effect in the sky area, while the rest of the image retains its colour.

• Contrast filters. These are used exclusively in black-and-white photography and they manipulate the image contrast. This manipulation is especially needed when two colours render the same tonality in black and white. The contrast manipulation would separate these two similar tonal areas, thus creating a more visually pleasing image. The basic rule for contrast filtration is that the filter would lighten its own colour and darken its complementary colour on the resulting print.

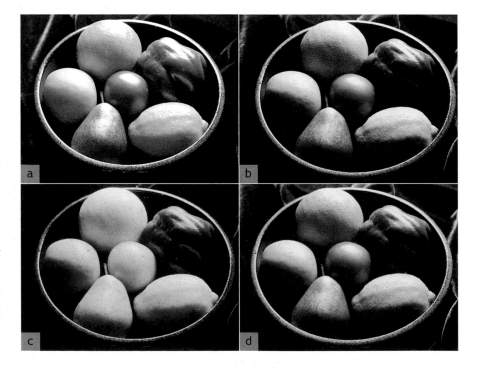

ABOVE: Filter use and effects. (a) Control shot. (b) Black-and-white 400 ISO film without filter. (c) Red contrast filter, which lightens red and yellow, while darkening green and blue. (d) Blue filter, which lightens blue and green, while darkening yellow and red.

FILTERS FOR BLACK-AND-WHITE FILM

Filter known as	Colour	Effect	Practical use	Factor with black-and-white panchromatic film	
				Daylight	Tungsten
8	Yellow	Absorbs ultraviolet and blue-violet.	Darkens blue sky to bring out clouds. Increases contrast by darkening bluish shadows. Reduces haze.	2	1.5
15	Deep yellow	Absorbs ultraviolet, violet, and most blue.	Lightens yellow and red subjects such as flowers. Darkens blue water and blue sky to emphasize contrasting objects or clouds. Increases contrast and reduces haze more than #8 filter.	3	2
25	Red	Absorbs ultraviolet, blue-violet, blue and green.	Lightens yellow and red subjects. Darkens blue water and sky considerably. Increases contrast in landscapes. Reduces haze more than #15 filter. Used with infrared film.	8	6
11	Yellowish-green	Absorbs ultraviolet, violet, blue and some red.	Lightens foliage, darkens sky. For outdoor portraits, darkens sky without making light skin tones appear too pale. Balances values in tungsten-lit scenes by removing excess red.	4	3
47	Blue	Absorbs red, yellow green, and ultraviolet.	Lightens the blue subjects. Increases bluish haze.	8	16
1A and 1B or UV	Skylight Ultraviolet	Absorbs some ultraviolet.	Most often used in colour photography, but also has some effect on black-and-white film. Eliminates ultraviolet which film will record as haze. Improves contrast in mountain, marine, or aerial scenes.	1	1
ND	Neutral Density	Absorbs equal quantities of light from all light frequencies.	Increases required exposure so camera can be set to wider aperture or slower shutter speed.	Varies with density	
	Polarizing	Absorbs light waves travelling in certain planes relative to the filter.	Reduces reflections from nonmetallic surfaces such as water or glass. Penetrates haze by reducing reflections from atmospheric particles. Darkens sky at some angles.	2.5	2.5

FILTERS FOR COLOUR FILM

Filter	Colour or name	Type of film	Effect	Practical use	Increase in stops	Factor
1A and 1B or UV	Skylight Ultraviolet	Daylight	Absorbs some ultraviolet rays.	Reduces ultraviolet which film records as blue. Used for snow, mountain, seascapes.	–	–
81A	Yellow	Daylight	Absorbs ultraviolet and blue rays.	Stronger than 1A filter. Reduces excessive blue in similar situations. Shooting on overcast days, in open shade.	$\frac{1}{3}$	1.2
		Tungsten		Corrects colour balance when tungsten film is used with 3400K light sources.	$\frac{1}{3}$	1.2
82A	Light blue	Daylight	Absorbs red and yellow rays.	Reduces warm colour cast of early morning and late afternoon light. Corrects colour balance for Type A film used with 3200K light source.	$\frac{1}{3}$	1.2
		Type A			$\frac{1}{3}$	1.2
80	Blue	Daylight	Absorbs red and yellow rays.	Stronger than 82A. Corrects colour balance for daylight film used with tungsten light.	$2\frac{1}{3}$ (A) 2 (tungsten)	5 4
85	Amber	Type A or tungsten	Absorbs blue rays.	Corrects colour balance when indoor film is used outdoors. Use 85 with Type A film, 85B with tungsten film.	$\frac{2}{3}$	1.5
FL	Fluorescent	Daylight or tungsten	Absorbs blue and green rays.	Correction of blue-green cast of fluorescent lights. FL-D used with daylight film, FL-B with tungsten film.	1	2
CC	Colour compensating			Used for colour balancing. Red, green, blue, yellow, magenta, cyan (R, G, B, Y, M, C) in various densities indicated by CC10R, CC20R, etc.	Varies	
	Polarizing	Any	Absorbs polarized light (plane of light waves relative to filter).	Reduces reflections from nonmetallic surfaces, such as water or glass. Penetrates haze by reducing reflections from atmospheric particles. The only filter that darkens a blue sky without affecting colour balance.	$1\frac{1}{3}$	2.5
ND	Neutral density	Any	Absorbs equal quantities of light from all parts of spectrum.	Increases required exposure so camera can be set to wider aperture or slower shutter speed.	Varies with density.	

- Colour conversion filters. Because light sources other than daylight or flash have different colour temperatures, they will give the image a colour cast (see p31). The image alongside was taken with colour transparency film under incandescent light, using an 80B filter to eliminate a yellow cast and achieve a neutral result. In other instances, however, the warm cast could be the desired effect, rather than detract from the image. Colour conversion filters convert a particular colour film for use with

a particular light source; for example, making it possible to use tungsten-balanced film to photograph in daylight.

- Colour compensating (CC) filters. Professional photographers use these gelatine filters for precise colour balancing. They compensate for slight variations in colour film batches or to make subtle changes to colour balance.

There are no rules and the only real mistake you can make is forgetting to take the filter factor into account.

FILTER FACTORS FOR GENERAL PICTURE-TAKING WITH BLACK-AND-WHITE FILM

Filter number	Colour of filter	Daylight		Tungsten light	
		Filter factor	Open the lens by (f-stops)	Filter factor	Open the the lens by (f-stops)
3	Light yellow	1.5	$^2/_3$		
4	Yellow	1.5	$^2/_3$	1.5	$^2/_3$
6	Light yellow	1.5	$^2/_3$	1.5	$^2/_3$
8	Yellow	2	1	1.5	$^2/_3$
9	Deep yellow	2	1	1.5	$^2/_3$
11	Yellowish-green	4	2	4	2
12	Deep yellow	2	1	1.5	$^2/_3$
13	Dark yellowish-green	5	$2^1/_3$	4	2
15	Deep yellow	2.5	$1^1/_3$	1.5	$^2/_3$
23A	Light red	6	$2^2/_3$	3	$1^2/_3$
25	Red	8	3	5	$2^1/_3$
29	Deep red	16	4	8	3
47	Blue	6	$2^2/_3$	12	$3^2/_3$
47B	Deep blue	8	3	16	4
50	Deep blue	20	$4^1/_3$	40	$5^1/_3$
58	Green	6	$2^2/_3$	6	$2^2/_3$
61	Deep green	12	$3^2/_3$	12	$3^2/_3$
Polarizing screen-grey		2.5	$1^1/_3$	2.5	$1^1/_3$

What equipment to choose

A great deal of your practical work will depend on your equipment, which in turn depends on the area of photography in which you have the most interest.

If you enjoy landscape photography you will need, in addition to a 50mm lens, wide-angle lenses to show dramatic vistas, or telephotos of between 70mm and 200mm to highlight areas of interest close up. Filter choice would be polarizing and neutral density, with a range of contrast filters if you are working in black and white.

Nature and wildlife photography would require either macro – for extreme close-up botanical shots – or longer focal-length telephotos for their magnification ability. These are prerequisites when photographing game or bird life. The choice of filters would be the same as for landscape photography.

In the genre of documentary and portraiture, it is important to get close enough to communicate with the subject. For this reason, photojournalists and documentary photographers like to use wide-angle lenses. The result is an image in which you have become a participant, rather than a witness. However, you need to make sure that by working close up you do not intimidate the subject. Nor

do you want the image to show the subject's response to your presence, rather than the event you are documenting.

Longer focal-length telephotos (100mm–200mm) would also be useful for those shots where you just cannot get close enough.

Depending on the type of assignment, photojournalists' work can be unpredictable. For that reason they like zoom lenses which allow for the fact that they cannot always dictate where they stand relative to the subject and that there may not be time to change lenses.

The longer focal-length lenses (80–200mm) are suitable for most portraiture work. If you are shooting an environmental portrait, a wide-angle lens will be workable, but you will have to deal with linear distortion.

When it comes to the use of filters, documentary photographers and photojournalists have to be disciplined – they cannot manipulate or alter the reality of the situation. However, using a polarizing filter to eliminate excessive reflections and the use of colour conversion filters are acceptable because they are unlikely to alter the content of the image. The same usually applies to portrait photographers, unless the photograph is to be used in advertising or beauty shots, where manipulation is acceptable.

ABOVE: This image was made by side-lighting holographic paper. Interesting effects can be achieved when photographing this paper because different colours are reflected each time the direction of the light is changed.

PRACTICAL TWO
Reflectors and Filters

Still life at a window

1. Set up a few still life objects on a table next to a window. The light from the window should be bright enough to create distinct highlight and shadow areas. Take a highlight-and-shadow reading and make a note of the lighting ratio.
2. Use the highlight reading throughout, because the point of the exercise is to show the effect of a reflector on the shadow area.
3. Use a mirror to fill in the shadow area (specular reflection) and shoot.
4. Use a polystyrene board (diffuse reflection) and shoot.
5. and 6. If you are using colour films, shoot photographs with reflectors of different colours and even gold.

Working with different lenses

Select three different focal-length lenses — wide angle (24mm), standard (50mm) and telephoto (105mm) — and shoot a series of photographs of the same landscape, without moving your position or the angle of the shot.

Lenses and perspective — Portrait in a landscape

Shoot the same photographs as above, but place a human being in the landscape and stand about 3—5m (10—16ft) away. The viewer will invariably look at the person first, before looking at the landscape, thus changing the way in which the photograph is perceived. The angle of view, magnification and visual impression are still factors that influence the resulting image, but the human can change the viewer's reaction to the photograph.

Working with filters

1. Contrast. Shoot a landscape on black-and-white film using yellow, orange and red contrast filters. These filters affect the sky because they are the complementary colours to blue and will increase detail and contrast. Yellow will darken the sky slightly, orange will give a darker sky and red can render it very dark. These effects are particularly noticeable when there are clouds.
2. Colour conversion filter. Shoot a still life or portrait indoors with daylight colour film using a candle or any other incandescent light source (light produced by a heated filament). Then shoot the same photograph under the same lighting, using an 80A or 80B filter to remove the colour cast created by the light. Compare results.
3. Polarizing filter. Shoot a series of seascapes and experiment with partial to total elimination of reflections with the use of a polarizing filter. If you live inland, you can experiment with the elimination of reflections off a lake or a snowscape.

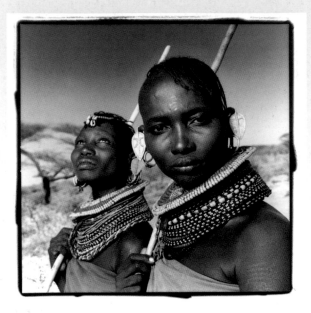

PHIL BORGES
Portraiture

The nature of a documentary photographer's work is similar to that of a photojournalist, although the approach and the final use of the images differ. Documentary photography records life as it is, the way people experience it, as opposed to how they would like it to be. It can also serve the important function of making a visual record of something that is about to become extinct. Ansel Adams, for instance, left a legacy of photographs showing the beauty of the wild places of America, while Phil Borges has created a record of tribal cultures in remote parts of the world. Borges has been documenting these disappearing cultures for over 25 years.

Borges says that on return from a trip to Mexico in the late Sixties, he saw the 'terrifying loneliness' of his own culture from a new perspective. He noticed the silence, the space between people, their avoidance of eye contact and, for good reason, of physical contact. Ironically, in those remote areas where an entire way of life is under threat, the people are less fearful than city dwellers – their eyes search, reach out to you and show their dignity.

Borges's photographs capture the dignity of his subjects. His photographs show the serenity in their eyes – despite the imminent disappearance of their way of life.

A selection of his work, titled *Spirit of Place*, explores the spiritual relationship between people and their land. Borges shoots with a medium format, square negative in black and white. This makes it possible to render detailed compositions without the subjective influence of colour. The black-and-white medium seems to reinforce the strength of his subjects.

TOP: Echuka and Eragai of the Turkana tribe are good friends who had walked all day in 43°C (110°F) heat to the market in Baragoi to get salt for their camels and goats. They called me The Fish because of the quantity of water I was drinking. They didn't seem to need to drink at all. The four cowrie shells on Eragai's head indicate that she has had a miscarriage. She will wear the shells for the rest of her life.
RIGHT: When he was a child, Roy Pete of the Navajo tribe had 'visions of my people coming home.' He has attended powwows for 20 years now and says many feelings arise while dancing in the ceremonial circle. 'You come to an understanding that you are part of a much larger process and very connected to it,' he told Borges. 'It is such a feeling of returning.' Roy works as a software engineer in Wyoming.

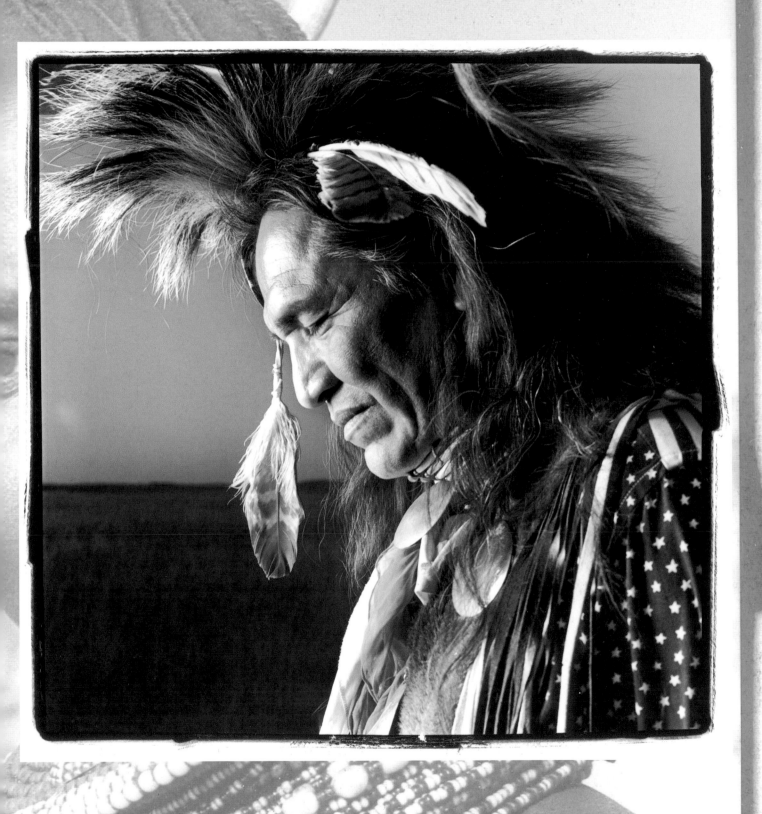

CAMERA TECHNIQUE 1

Your camera technique, and thus your photographs, will improve with understanding of the underlying theories of photography. Whatever your area of speciality, the basic guidelines remain the same.

Let's assume that you are photographing a family of five people. First you need to decide how you would like to portray the group – a posed picture (three in the back row, two in front) or a close-up of five faces, for instance.

This choice would be influenced by, for example, how relaxed these people are in front of a camera. If you moved in too close they might be intimidated. On the other hand you may want to include some of their environment, or the family dog.

This decision would lead to lens selection. The best lens for a close-up shot would be 70–105mm and for a group including their environment, 28–35mm.

Once you've decided on the lens you are going to use, you will have to accept the effects created by the characteristics of that focal-length lens (see p61).

Depth of field

To make a photograph with maximum focus, that is, with the whole picture space clearly focused, you must use a small aperture (f16 or f22) and manually focus on a point one-third of the distance into your picture space. You will use this effect for a large group at a wedding or for a landscape.

Selective focus

Sometimes, however, you need to highlight your subject with focus because the background is busy and has no relevance to what you want to say about the sitter. Or you

TOP RIGHT: An architect photographed in his design studio. The format and depth of field are the techniques used to show all the elements associated with his work.

ABOVE RIGHT: The vertical image is closer in, selectively focused and concentrates on the architect only.

may want to ensure that the viewer looks only at the subject and nothing else. When you work with wide apertures such as f4 or f5.6, you have to be exact with your focus. For a portrait, play it safe and focus on the eyes. The basic rule still applies – one-third in front and two-thirds behind the point of focus. However, the depth of focus is more limited.

The photographs, opposite, of an architect illustrate the process. An architect's business is about working with space. Here the depth-of-field technique was used to include his working space. Each element was included to give the viewer a visual clue about his work. The vertical picture, however, shows the same subject closer in, selectively focused; attention is concentrated on the architect exclusively, diminishing the importance of background in the picture.

Freeze action

When photographing moving subjects such as sprinters, motor racing, etc, you need to focus on the fast-moving subject, freeze the action and prevent the surroundings from detracting from this action (see left, top).

For this you need a fast shutter speed, such as ⅟₅₀₀th or ⅟₁₀₀₀th of a second. You also need to follow the subject's movement with your camera (panning) and shoot at the appropriate time. Panning will blur the background. A busy background, unblurred, will detract from the main subject (see left, centre).

Showing movement

Sometimes freezing the action can destroy the sense of drama. A cyclist frozen against a blurred background may show good action, but not the sense of speed (see left, bottom). This becomes particularly apparent when shooting fast-moving subjects like racing motorcycles. In this case you can capture the sense of speed by showing the movement of the motorcycle as a blur.

You can enhance the effect by panning as well. This is an instance when sharpness is not an issue. The amount of blur (movement) you want to show will dictate the shutter speed. Experiment with slower speeds of around ⅛th, ⅙th or ⅟₃₀th of a second.

TOP: Freeze action with fast shutter speed and panning.
MIDDLE: Freeze action with fast shutter speed, but without panning.
ABOVE: Show some movement with panning.

Working the subject

'If you think a picture is worth taking, then take two; in fact shoot a spool.' – New York-based commercial photographer, Jay Maisel.

When you have made a picture, how do you know whether you have captured it the best way possible? Have you approached it from every possible angle and viewpoint? Have you missed out any combination? Have you ever considered any of the above possibilities?

Refer back to the photographs you shot in Practical 2. Consider how the effect of focal length changed the communication value of the image. There, the variation had to do with focal length. In other images, however, your variations could be depth of field, selective focus or changing your viewpoint – e.g. from above or from ground level.

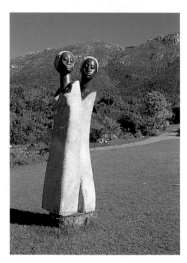

ABOVE: This illustrates the ideal encouraged by Jay Maisel. It is important to work around the subject and explore all the possibilities it affords.

Format

Format could refer to either the film size or whether you shoot on the horizontal or vertical. If you have a range of different cameras, this is also a factor to be taken into account (see p18). In a compositional sense, format refers to whether you shoot on the horizontal or on the vertical. Usually, one or the other format seems to work for a particular image, while in other cases you need to experiment with both views. By experimental shooting in both formats, you can make the decision while editing.

Taking all the above aspects into account should be part of your photographic routine, and once you can do this, your confidence will improve and so will your pictures.

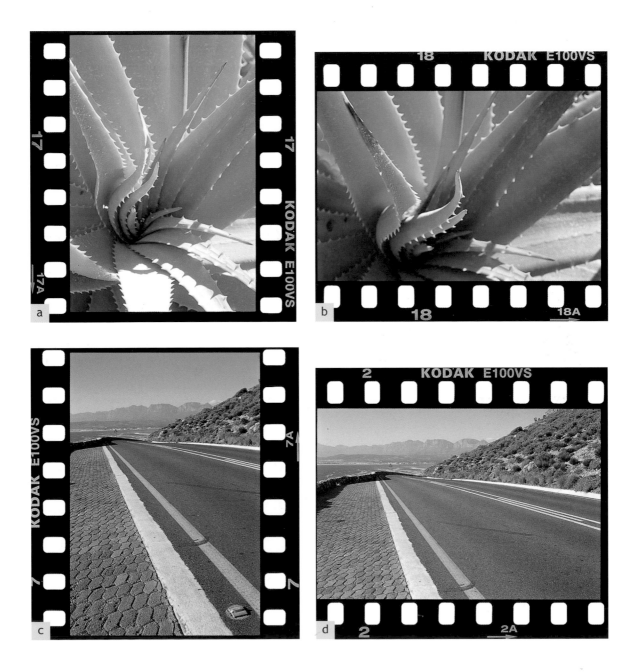

ABOVE: The vertical shot (a) is the better choice. In horizontal shot (b) the foreground consists of a dark area on the left and an out-of-focus light on the right. Of images (c) and (d), the horizontal shot is the better, giving a sense of the space of the landscape.

PRACTICAL THREE
Camera Technique

Depth of field

Using an aperture of f16 or f22, photograph a shopkeeper behind a counter or a street vendor on a busy street. Try to show how their environment explains part of what they do. Use visual clues, move in closer. Turn the camera to include horizontal and vertical shots.

Selective focus

Using an aperture of f4 or f5.6, shoot the same scene as above, but focus on the subject. Again, take both vertical and horizontal shots.

Freeze action

Panning is easier if you have a tripod. Shoot any fast-moving object using a shutter speed of $\frac{1}{500}$th or $\frac{1}{1000}$th of a second. Take some shots without panning and compare the results.

Show movement

- Shoot the previous scene using a shutter speed of $\frac{1}{8}$th or $\frac{1}{15}$th of a second. Shoot with and without panning.
- Find a waterfall or flowing river, or go down to the sea. Use a shutter speed of around a $\frac{1}{2}$

ABOVE: The movement of the ocean and wave was photographed using $\frac{1}{8}$th shutter speed. This enabled the moving spray to be softened and blurred rather than frozen as an action shot.

or a ¼ second, but without panning. The result will show a blur of water in a pin-sharp landscape (see opposite page).

Working the subject

Select a landscape that includes rocks. Compose the landscape so that the rocks feature prominently, without dominating the landscape. Shoot for maximum depth of field.

Move closer to the rocks so that the rocks dominate the composition and shoot. Move even closer and photograph the rocks in such a way that they are completely abstracted, i.e. there is no landscape, but the frame is filled with the texture of the rock.

Compare the results. You will notice that the form and structure of the rocks change as you change your viewpoint. Shoot around the subject completely, holding the camera for both horizontal and vertical shots until you have exhausted all the possibilities the subject has to offer.

Notice how the visual impression changes: the further out, the more depth of field; the closer in and the more selective your focus, the less depth of field.

Format

Compare the images you have shot so far. Decide whether the horizontal or vertical format was most successful in each photographic situation.

Point of focus

The purpose of this exercise is to help you understand the importance of point of focus when working with depth of field and selective focus.

Set up a line of six people, equidistant and one behind the other, in a slight diagonal away

from you so that you can still see each person. Set your camera on a tripod about 2m (7ft) from the first person. Neither the camera nor the people should move from their positions throughout this exercise.

1. Set the aperture to f16, take a light reading and set your shutter speed. Focus on the first person and shoot. Then focus on each successive individual and shoot.
2. Set the aperture to f5.6. Take a light reading and set the new (faster) shutter speed. Focus on and photograph each successive individual, exactly as before.

Examining the results, you will notice that in the first instance, when you focused on person number two, all six people were in focus. The small aperture gave you maximum depth of field. However, as you focused further into the picture, the foreground persons became less sharp.

With the aperture set at f5.6, the narrow band of focus (limited depth of field) associated with wide aperture is apparent as the sharpness drops off rapidly to both sides of the person being focused on.

ABOVE: This wide-angle environmental portrait uses the selective focus technique to highlight the interaction between the boy and his cat.

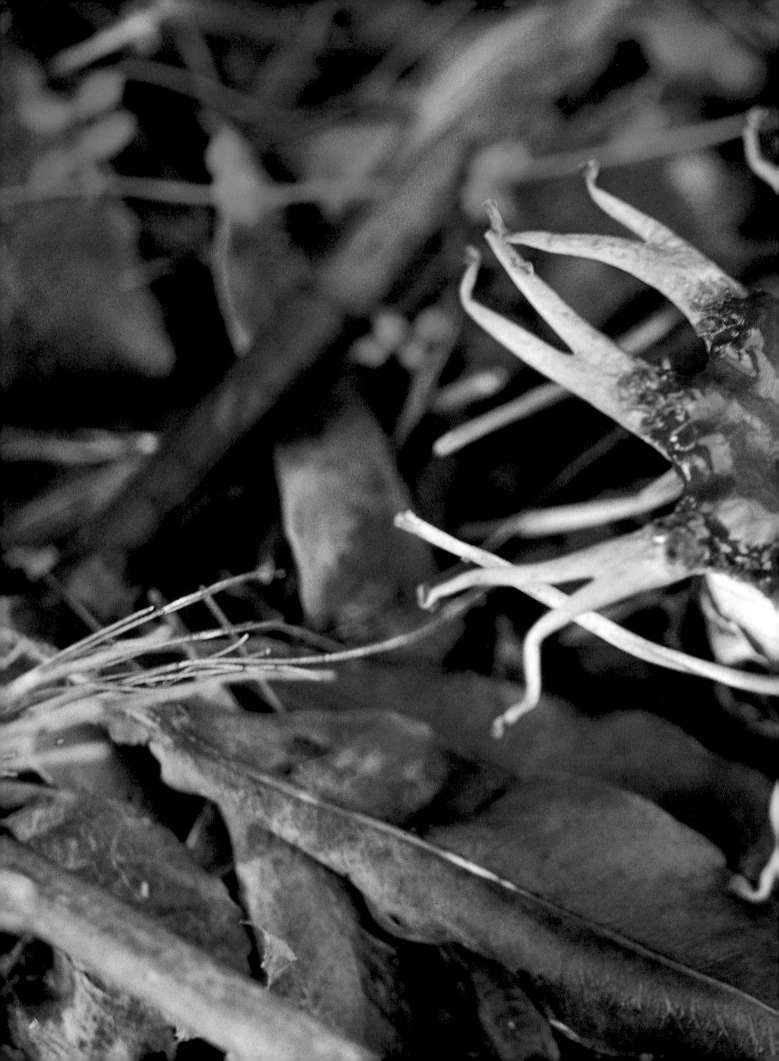

COLOUR

The human eye is able to differentiate between wavelengths, which it perceives as colour. As discussed in the earlier chapter dealing with light (see p30), white light is made up of all the colours of the rainbow, each with its own wavelength. When light strikes the surface of an object some wavelengths are absorbed, while others are reflected. If the surface absorbs all wavelengths except that of red, we perceive the object as red.

Structure of colour film

Colour film consists of many layers, depending on the type of film, but three of those layers have the same structure as the emulsion of black-and-white film. The image is captured by the silver halide crystals as the light causes molecular changes when it strikes them. However, with various colour filtration, each of these black-and-white emulsions is only sensitive to a third of the visible

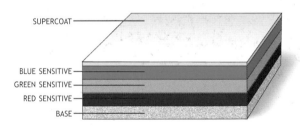

spectrum. Depending on the type of film, colour couplers are either integrated with these emulsions or colour dyes are added during processing, producing complementary colours to those that the emulsion is sensitive to.

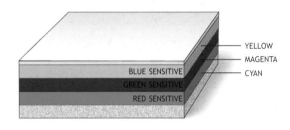

If you look at the colour wheel you will see that each of these dye colours (also called subtractive primaries) represents two-thirds of the visible spectrum. Combinations of these colours create the colours rendered on film or paper.

ABOVE LEFT: A cross section of colour film, showing the three sensitive layers.

TOP RIGHT: An enlarged cross section, showing colour couplers in the emulsion of colour film.

Colour film types

There are three types of colour film: colour negative and two types of colour transparency (also called slide or positive film). One type of colour transparency (the one developed with the E6 process), contains the colour couplers, similar to colour negative film. This film is relatively thick and more difficult to bend, often leading to tearing in extremes of hot or cold weather. The emulsions, and therefore the images, begin to break up after eight or nine years. The other type of transparency film, Kodachrome, has colour dyes added at the processing stage. It is thin-ner, less likely to tear in extreme temperatures and the images remain stable for more than 30 years. Kodachrome requires processing by special laboratories. Colour transparencies have better colour saturation than colour negatives. A high-colour version of E6 process film is available for photographers requiring even higher colour saturation.

Transparencies tend to be more contrasty than negatives, but have minimal exposure latitude – a third or half of a stop, so ensure that the highlight areas are correctly exposed. They give the best quality, but are more expensive to print. Therefore, if multiple prints will be required

ABOVE: When working with colour, red always dominates the composition.

from a shoot, then negative film would work out cheaper. The **colour temperature** (see p31) of the light source you are using will affect the colour of the resulting photograph (see practical one).

Colour film is manufactured for use with different colour temperatures. Daylight film is balanced for use with a 5800K light source. Tungsten-balanced film is used with light sources of 2800–3800K. However, the latter is not as widely used as daylight-balanced film, since most photographers find it simpler to use a colour conversion filter instead (see p67).

Guidelines to ensure good rendition of colour

- Experiment with different brands of film until you find the one you prefer.
- Process film as soon after exposure as possible.
- Keep unexposed film in a cool place.
- Keep colour temperature in mind. Select a film to match the light source.
- Colour negative and transparency film run through different processes (E6 and Kodachrome for slide and C41 for colour negative), usually printed on the film box and cassette. Some laboratories may only be equipped to do one

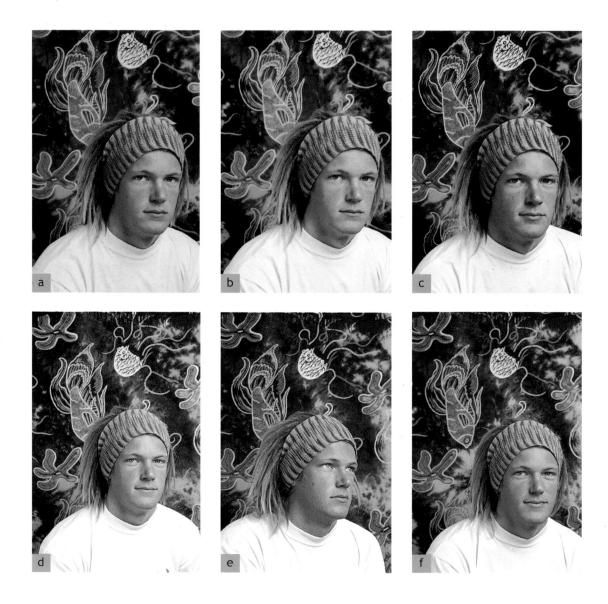

ABOVE: These photographs show the different renditions of colour by a selection of colour transparency and negative films: (a) Kodak 400N, (b) Agfa Optima (100), (c) Fujicolour 200, (d) Kodak E 100VS, (e) Fuji Velvia 50, (f) Agfa RSX 50.

combination of two, will have to be used to remove colour casts. The rule is to either subtract the cast colour or to add its complementary (see colour wheel on opening page).

At first it is difficult to recognize the colours. The inexperienced eye finds it difficult to distinguish between a red and magenta cast, while blue and cyan also look similar. If you have colour correction filters, study the varying densities of these colours. This can help you analyze colour prints and ensure that you get the best possible result from your negatives.

particular process, so check with them first. If you make a mistake here, the results can be interesting (see above).

- As much as possible, stay with the same laboratory. Find a printer that produces good quality prints. If the quality of the work is not to your satisfaction, ask for them to be reprinted – you are paying good money, make sure you are satisfied with the results. Colour casts occur due to technical mistakes or poor printing.

Troubleshooting colour print problems

- Underexposed negatives produce dark, flat, greenish prints with grain.
- Using daylight film under incandescent or tungsten light gives a yellow cast – use tungsten film or an 80B colour conversion filter.
- Daylight film under fluorescent light gives a greenish cast. Use a fluorescent filter (see p66) or shoot colour negative and ask the printer to add magenta.
- Tungsten film under daylight conditions gives an ice-blue cast. Use a colour conversion filter.

Colour casts

A pair of subtractive primary colours – e.g. yellow and magenta or cyan and yellow, etc. are used to make colour prints. One of the three subtractive primaries, or a

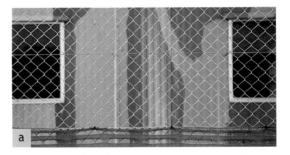

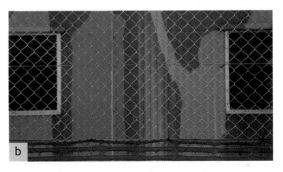

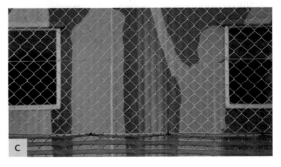

TOP: The American flag was photographed using colour negative film and processed as slide film.
ABOVE RIGHT: These photographs illustrate the subtleties of colour shifts: (a) neutral, (b) a percentage of red and (c) a percentage of magenta.

PRACTICAL FOUR
Light and Colour

Choice of film

One of your first considerations when working with colour is whether to use transparency or print (see p81). For the following exercises the choice is yours.

Light and colour

Just as the Impressionist painters discovered how light revealed colour, you need to discover the relationship between light and colour. In practical one (p44), your experiments showed the effects of the different colour temperatures from different sources of light. In this exercise, you will be using natural light and recording the shift of colour temperature during the day.

Choose a convenient photographic location close to you that will show the effect of sunlight. Compose your photograph so that the sun is behind you at noon (facing north if you are in the northern hemisphere and facing south in the southern hemisphere). Use 100 ISO daylight film.

Photograph this scene in the early morning, at noon and again in the evening. Choose clear, sunny days, and the setup should not alter in any way (i.e. position of the camera, composition, lens focal length). The camera settings will change, because the intensity of light will be different, but try to be as consistent as possible. The results will show how the colour of light alters during the day and also how direction of the light can alter the way in which the subject is represented.

If possible, extend this exercise by repeating the series for each season of the year, although you may not always have sunlight. The season pictures will give you a feel for the intensity of sunlight and, if you manage to capture winter sunlight, you will see how much softer it is than summer sun.

Indoor

Available light

Experiment with colour photography indoors, without flash, using only available light.

Set up a still life or a person for a portrait. Use 400 or 800 ISO daylight film. Do not use any light source other than ambient light.

1. Measure the light, using the highlight-and-shadow method. Determine the lighting ratio (see p36).
2. Set the camera for the highlight reading and shoot a frame.
3. Fill in the shadow areas with a polystyrene reflector board, and take another reading of the shadow area. Recalculate the ratio. You will notice that it has been reduced.
4. Still using only the highlight reading, shoot another frame.
5. Experiment with a candle or an ordinary light bulb to fill in the shadow areas. In all cases the fill-in light must be less intense than the ambient light.
6. Shoot a frame each time you change the fill-in light, while using only the highlight reading.

Result

The result of this exercise will depend on the intensity of the ambient light primarily and show the effectiveness of the fill.

In (2) the lighting ratio will be quite evident and the contrast will be at its greatest. In (4) you will have reduced the contrast by the use of the reflector board. In (6) your fill will have the warm glow of the colour temperature from the candle or other incandescent light source. If the yellow glow in (6) suffuses the entire photograph, that means the fill was stronger than the ambient light and became the main source of light, with the ambient light as fill.

Test the film

Find a multicoloured object or set up a still life containing as many colours as possible, including a skin tone. Select a range of different colour films — different film speeds and brands of slide and negative. Shoot this same subject, under identical lighting conditions, with your selection of films. Shoot the same subject in sunlight, and indoors with flash and incandescent light. Whatever variation you decide upon, you need to do it with all the films, and within the same time frame, otherwise you will not be able to make the comparison.

Make notes to keep track of which frames were shot under each of the different conditions. The idea behind this task is to see how the different films render colour and, in the process, you may also discover which brand you prefer. Remember to process all the films at the same laboratory, ensuring that all those of the same process type are developed in the same run.

Low light

Shooting cityscapes at sunset can result in dramatic pictures because of the range of different lights, each with a different colour temperature, that come into play as the intensity of the

sun decreases. Experiment with 800 or 1600 ISO film. Beware of reciprocity failure (see the chapter on film, p47) and bracket on the overexposure scale for at least three stops. Remember that as the sun sets, you will rapidly lose light in the sky areas. Shoot quickly, while continuing to evaluate the light.

Cross process

Shoot off a roll of transparency film, varying your subject matter from portraits to landscapes to still life to nude. For some of the pictures use different sources of light and in others use yellow or green contrast filters over your lens. Ask the laboratory to process for colour prints (C41). The resulting prints will show weird and wonderful colour combinations.

ABOVE: Bright colour, blue sky and good light are the ingredients of a successful colour image.

ALEX WEBB
Composition & Colour

Alex Webb joined Magnum Photos in 1976 and since then his work has appeared in magazines, books and exhibitions in the United States and Europe. He has won various grants, fellowships and awards, and is considered one of the greats among contemporary colour photographers.

He made most of his photographs while on assignment as a photojournalist, but also turned his camera to a deeper, more contemplative purpose. The strength of his work lies in his mastery of the emotive and subjective use of colour and the ability to draw the viewer into his world.

Webb says he has a 'tropical obsession' – he loves the light and colour of the tropics; and his work explores all these 'hot-light places' – Haiti, the Amazon, Latin America, Florida (the Sunshine State), Mexico, Africa, Asia and, more recently, Cuba.

He has the uncanny ability to choose the moment when the colour works best for the picture content so that colour becomes more than just a realistic representation, but also visually explains the mood he is trying to convey. For instance, he might juxtapose a crowd against a red bus, which amplifies their agitation, further emphasized by a low angle of view.

Sometimes Webb's use of colour is more subtle, but nevertheless just as powerful as the bold in-your-face colour of many of his photographs. In the photograph opposite, the content is the intimate moment shared by the couple. The intensity of this moment is emphasized by the

red which is further enhanced by the small area of blue in the background. He could have gone in close and just photographed the couple, but by working their environment into his composition he has created a highly communicative image.

He uses complementary colours and by placing them against a neutral brown background, Webb is able to make us feel the heat of the day, the intensity of the sun and the lassitude of the subjects. And each time he chooses the moment when the colour works well, and interacts with the subjects.

Sometimes his images have a 'video freeze-frame' quality – one has the feeling that the figures will move again as soon as the pause button is released.

Another aspect of his work is the ability to photograph at contrasty times of the day, characterized by silhouettes. In these instances he would have to ensure that the highlight areas are correctly exposed, leaving the shadow areas with little or no detail.

Alex Webb's images will change the way you look at colour photographs.

TOP: In this complex composition Webb has fused the figure/ground relationship. The light enhances the composition, and the shadow it creates also becomes a compositional element.
RIGHT: In this image Webb enhances the decisive moment by the subtle use of composition and complementary colour.

COMPOSITION

The word composition is defined as 'putting together into a whole' or 'the arrangement of parts of a picture.' Each element in the picture must have a function – it needs to work within the arrangement. If not, it will merely detract from the whole. Some photographers see compositions better than others; they know intuitively where everything goes, while considering all the technical aspects that would affect the image they see in the viewfinder.

Rather than slavish obedience to, for instance, 'the rule of thirds' (the division of a photographic space into thirds on the vertical and the horizontal; and the placement of the compositional elements within these points), the most successful photographic compositions result from the photographer's spontaneous reaction to a scene.

A composition consists of
- one or more objects or elements
- background
- light, which may or may not be a compositional element
- colour and contrast, which may be used as tools to enhance mood or atmosphere.

Composition is affected by
- choice of lens and range of viewpoints
- perspective – the relationship between the photographer and the object and the relationship between objects
- scale – size of the subject in relation to the content
- framing – which guides the viewer into the picture
- the figure/ground relationship – the integration of the object with the foreground and background.

ABOVE: A well-rendered photograph ensures that the subject, background/foreground, light and colour work well together, supporting one another to achieve a balanced composition.

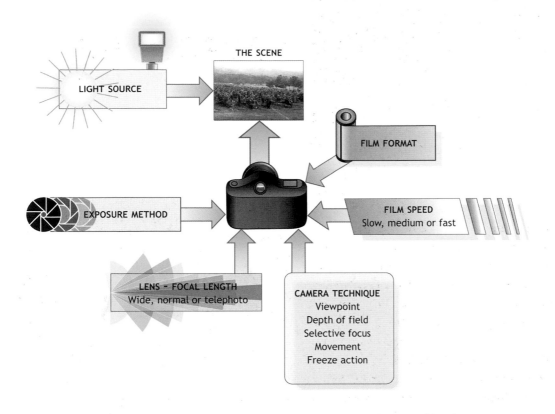

Light source	Intensity (distance) and quality.
Exposure method	Depends on intensity of light; qualities of subject.
Film format	Dictates quality of result; picture area you will be using.
Film Speed	Dictated by the intensity/quality of light; inherent contrast and resolution.
Lens focal length	Angle of view; magnification; visual impression.
Camera technique	Choice of viewpoint; depth of field/selective focus; freeze or show movement.

ABOVE: A mindmap of all the considerations involved in making a picture.

Guidelines to good composition

Rather than provide a formula, here are some guidelines that will help you recognize a well-composed picture.

Graphic composition

The graphic approach leads to a very simple, two-dimensional composition. You treat the scene as if it were flat – it has no depth. In other words, the background has no prominence or importance in the picture.

One-object composition

A single object can be difficult to work into a composition. Avoid putting it in the centre, which makes the picture boring and static by negating the space around it. You can use the background to enhance what you want to say about the subject by giving the viewer visual clues. The use of depth of field or selective focus controls the amount of information you give the viewer. However, the reason for shooting a single-object composition is usually that this is the area of importance. So, whatever technique you use, keep in mind that it must not detract from the main subject or communication value of the image.

ABOVE: Compositional styles: (a) Graphic – this picture is flat and two-dimensional. The viewer will look at the monument only. (b) One object – the subject dominates the composition. (c) The designer at his computer dominates the picture; the environment sets the scene, but is unimportant.

have to show their interrelationship as well as their relationship with the background. Whether the picture is of two people, or of a single person and a building or a vehicle, you will have to work all these elements into the whole arrangement and it is up to you to determine the relationship.

The use of scale can exploit these situations. The subject can dominate the space when positioned close to the camera, or become an integral part of the space if placed further back, away from the camera. In some cases, such as the artist in the photograph above completely surrounded by her wares, the figure/ground relationship becomes integrated. Another example could be of a cyclist shown in silhouette (black), where the background is a flat colour.

Two-object composition

When dealing with two objects, each of which has equal importance in the picture frame, your composition would

ABOVE: (d) The subject, highlighted by focus, is surrounded by her art and they become one. (e) Two objects: the tree and the window create a dramatic line leading from the foreground to the background. (f) The relationship between the child and his grandmother is the content of the image.

Symmetry in composition

Photographers often make use of symmetry when shooting architecture because it can be very pleasing to the eye. A symmetrical composition gives equal weight to two sides of the frame, from the central point. It can, however, be static and boring. The photograph of the monument on page 90 is an example of a graphic, symmetrical composition that lacks interest or drama. However, the photographer could add something to tip the balance by, for instance, juxtaposing complementary colours or by including a ray of light, or human interest (see p103). This will be sufficient to tip the composition over to asymmetry.

ABOVE: The Venetian piazza has symmetrical arches. However, the balance has been tipped towards asymmetry by the inclusion of a waiter and the birds. Cover these elements with your finger, assess the image, and then look again with the birds and waiter included.

Classical composition

This consists of multiple elements that work together as a whole. You can use framing to lead your viewer into the picture, diagonal lines to lead them to vanishing points, or you can link areas of the image with colour, tone, pattern or subject gesture to create a circular movement or S-flow. The vanishing point is the area to which the eye is drawn by the compositional elements. In the image of the lake below, the line of the water's edge and the trees lead the eye deep into the picture.

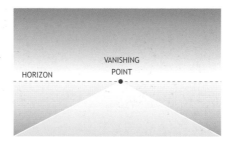

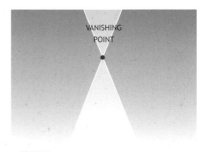

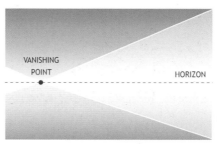

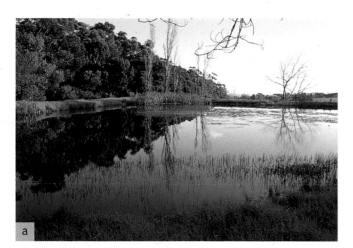

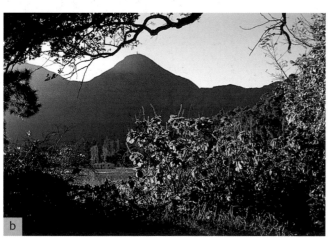

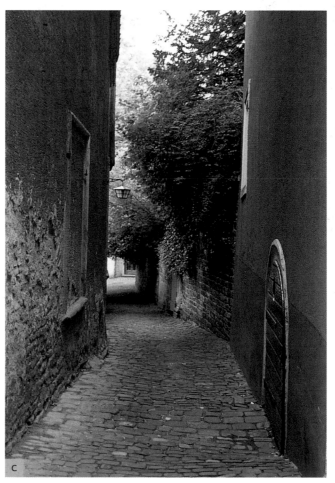

ABOVE: (a) A classical landscape. The viewer is drawn into the picture by a diagonal line. The shady foreground is balanced by the light blue sky detail. (b) The framing technique is used here to lead the viewer into the picture space. (c) The eye follows the winding street to the vanishing point.

93

Three-dimensional composition

This is the opposite of graphic composition. It involves working with multiple objects, extreme depth of field and often busy backgrounds. This method is most successful in landscapes, cityscapes or architectural interiors where sharp detail is required. Usually, you will have to arrange several groupings of objects into the whole.

Enhancing composition

There are many subtle ways of making compositions more exciting or communicative by using the tools of light, contrast or colour.

TOP: Ben & Jerrys, New York City. This busy cityscape, shot wide angle to include as much detail as possible, employs the technique of grouping several collections of elements within the picture.
ABOVE: The light enhances the vibrant colour and form of these wild flowers.

- Light. You can use light – in the form of a ray, or its shadows on buildings or backgrounds – to improve your composition.
- Contrast. By juxtaposing areas of highlight and shadow you can create extremely powerful and moody compositions.
- Colour. Photographer Alex Webb (see p86) has the ability to juxtapose complementary colours in such a way that they create a tenuous thread drawing the foreground and background of the picture together, leading the viewer into the picture space. People or objects in semi-silhouette, contrasted against neutral browns, also draw the viewer in and emphasize the vibrancy of the complementary colours.

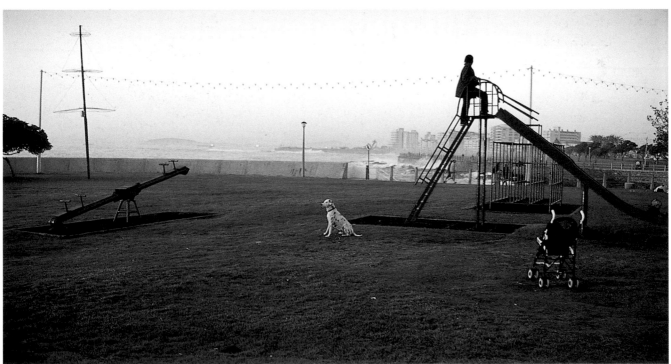

TOP: Light can be used to convey mood – in this image the clear light of early morning enhances the intense colour.

ABOVE: After sunset, the rosy glow and its warmth create a nostalgic atmosphere.

PRACTICAL FIVE
Composition and Colour

Themes

Select three themes for this exercise, e.g. landscape, nude, portraiture, still life, and so on.

For each theme, explore one or more compositional methods or guidelines that you feel best suit the topic. If your first theme is portraiture, try a graphic composition with no background at all, a one-object composition with some background telling us more about the primary object, and a two-object composition such as an environmental portrait of an artist with a sculpture in a studio or a cook with a culinary creation in the kitchen.

Colour

Select a single colour, and shoot a roll of transparencies exploring the emotive qualities you associate with this colour.

Before you shoot, write down all the words that you associate with this colour. Interpret these words with pictures or scenes in your mind's eye. Try to use literal as well as conceptual ideas to represent this colour. For example:

Blue: cool, soothing, sadness, refreshing, the sea, the sky, bluebells in spring, cold.

Some of these words are positive (cool, soothing), while others are negative (sadness, cold).

On the positive side, a mind picture depicting the word cool could be the sparkling blue water of a swimming pool on a very hot day and visualizing someone diving into and floating on the water. On the negative side, a mind picture depicting the word cold might be an empty room devoid of human warmth or character.

ABOVE: This photograph illustrates the use of light to enhance the rendition of colour.

Enhancing Composition

Take a photograph of the façade of a building, ensuring that the lines are symmetrical.

Make the same composition asymmetrical by the addition of a ray of light or shadows cast by trees or lampposts. This may involve shooting the second photograph at a different time of the day, or in different weather conditions.

Style

Find books published by famous photographers and analyze their style. Using this as inspiration, try to photograph a chosen theme using their approach to picture-making.

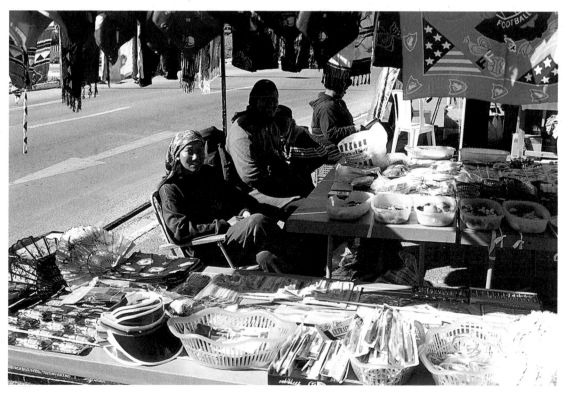

TOP: Early morning light enhances the mood created by the autumn leaves.
ABOVE: Brightly coloured wares frame this environmental portrait of stall holders, leading the viewer into the scene.

CAMERA TECHNIQUE II

If you look at the photographs of Alex Webb you'll find that, in one image, the colour might quiver and pulsate with emotion, while in another they might be soothing and give a warm glow. This subjective use of colour adds strength to the images, increases their communication value and contributes to their success – you feel that you have been there.

When working in colour, you need to consider how it can evoke feelings in the viewer.

Light

The evening light can be used to create a mood of warmth. Yellows and reds appear more saturated and rich, contributing to a mood of mellowness and contentment. Early morning light is clean and fresh. In this clear atmosphere, colours appear fresh and lively, but you need to work quickly before the light becomes hot and contrasty, as it will during the course of the morning, especially in the summer months.

ABOVE: The flattering, soft light of the setting sun enhances the mood and colour red in this image. At this time of day the colour temperature of the light is lower than at noon.

Complementaries

By placing complementary colours together, they are enhanced so that each appears more intense than it would by itself. However, some complementaries dominate one another – red will always be stronger than green.

Colour contrasts

Colours need not only be considered in contrast with each other – black and white areas in your colour pictures can also enhance the intensity and saturation of colour. Light colours are most striking against black areas. Dark colours become more striking against white or highlight areas.

The symbolism of colour

Show the colour red to a group of people and ask them to write down the first word they think of when they see this colour. Their responses will include words such as power, blood, hot, strength and dominance.

Red evokes strong feelings in the human psyche and the photograph, above left, shows how dominant it is.

Advertisers rely on our responses to colour and what they symbolize, such as red-hot and cool-blue, to induce or seduce us to buy. However, these responses are not universal and other cultures may have different associations.

ABOVE: Red dominates its complementary, green, in (a). Blue and yellow seem balanced in (b) despite the larger blue area. The intensity of the red in (f) and the blue in (e) are exaggerated by their proximity. Black or white can affect our perception of the intensity of colour, as in (c) and (d).

Colour event

The phrase 'colour event' was coined by American photographer Gary Winogrand to describe 'the meeting of light and colour'. It explains how the use of light can enhance a colour – and therefore the mood, atmosphere and communication value of the image.

Communication value and content

To evaluate the content and communication value of a photograph, you should start by asking yourself a few questions.

- Why have you made this picture?
- What does it contain?
- What is it communicating to the viewer?

There is also a difference between 'taking' or 'making' an image.

'Taking' tends to imply that you are removing something, without considering the consequences. It is as if you are taking evidence to prove that you have been there. 'Making', on the other hand, implies something more creative and spiritual. You have considered where you are; you have made use of the elements around you; and used these considerations to create a memento of your visit.

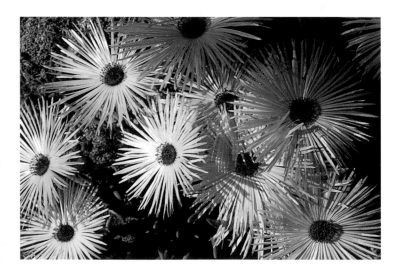

TOP: This simple seascape is an example of a colour event – the meeting of light and colour.
ABOVE: A more dramatic colour event – these wild daisies are back-lit, a technique also known as *contre-jour*, which seems to illustrate the energy of growth.

When, for example, you see a beautiful flower and want to have a reminder of its beauty, you photograph it – and there it is: forever beautiful. However, the beauty will be of a superficial nature. When you photograph a beautiful flower, try instead to show the essence of the beauty. Think about what really made the flower beautiful. I see the beauty of a flower as having to do with the process of growing – and I am not talking time-lapse photography here.

Incident

When you think about a remarkable image, try to identify what it was about that photograph that made such an impression on you that you remembered it. This is what is meant by 'incident' – some spark that communicates its content to you, leaving you with a memory of that photograph. New York-based colour photographer Jay Maisel exhorts his students to ensure that there is a climax in their pictures. This involves leading the viewer to a particular place in the photograph where something specific is happening (the climax or incident), thus communicating the content of the image and validating the picture. Part of the secret is in determining the right moment to photograph the subject. It is this moment that conveys what you have to say about what you see, that makes the photograph unique and makes it your own.

An event that can be used as an example, was the attack on the World Trade Center, New York City, on 11 September 2001, because it was documented by so many photographers, each deciding on a particular moment to shoot. So, although we were looking at the same event, each photographer's interpretation was different, which made each photograph unique and memorable.

As a beginner, capturing the right moment may not be the problem. You may well have photographed it. However, you may also have included unnecessary clutter in the picture space, which diluted the moment. Learn to be specific about what you are photographing; isolate the subject; lead your viewer to the climax or incident; make sure that what you want to say is captured in such a way that the viewer can share your interpretation of the moment.

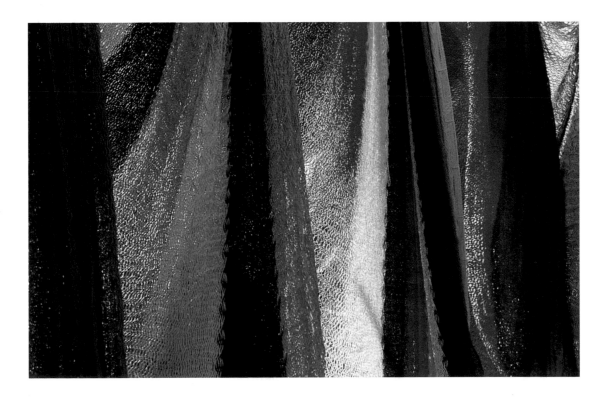

ABOVE: This image is a great colour event, with textural rendering that visually describes the nature of the subject. A photograph that is the quintessential rendering of any subject matter is said to have gesture – it is a perfect example of quality.

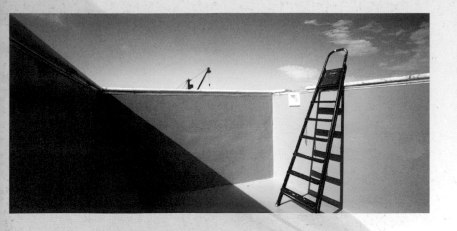

PHIL BEKKER
Simplicity and strength

The range of work produced by Atlanta-based photographer Phil Bekker is vast and visually inspiring. Bekker works in the field of advertising and corporate photography, but still finds the energy for creative work and to teach at the Arts Institute of Atlanta.

He uses a range of different format cameras – 35mm, panoramic, medium format SLR and view cameras. He has an extensive portfolio of images created with the use of Polaroid materials and an SX70 camera.

His landscapes pay homage to nature – the light, the colour and texture give the land monumental status, whether it be a canyon, a prairie or a wooded valley. His black-and-white images are moody, subjectively contrasty and have a peaceful, timeless quality about them.

The location work is devoid of human representation, but signs of man's presence are visible – a signboard, a railway crossing or a cultivated field speak of man's existence, but not his intrusion.

Bekker's use of colour is bold and his compositions are graphic in their interpretation (see opposite). This combination is used effectively in his exploration of small-town America. He often juxtaposes complementary colours, uses wide-angle lenses and works with an interesting angle of view – some seem very close to the ground, while others are more of a bird's eye view. His studio work carries the same trademark, with the addition of meticulous planning and superb lighting, resulting in beautifully rendered still life images.

This discipline is carried over and taken further in his own fine art work – the images are portrayed using Polaroid materials that have been manipulated during the development process. The difficulty in working with this material is the unpredictable nature of the process, but even here, when anything or everything can go wrong, Bekker triumphs – and he produces images of simplicity and strength.

Like Alex Webb, the strength of Bekker's work lies in his use of colour and composition. Where Webb's images are about the lives of people and their environment, Bekker explores colour and space with a keen eye and the resulting images are surprising observations about everyday, almost banal objects. Yet he creates **incident** with them.

Bekker has won numerous awards and accolades. His work has been published widely and he has exhibited internationally. His work is held in numerous private and corporate collections, which indicates how well understood his use of the visual language is. His photographs have gesture.

TOP: The strength of this graphic image lies in the use of complementary blue and red and the economical use of the compositional elements.
RIGHT: Bold juxtaposition of red, yellow and blue illustrates the successful use of colour in Bekker's images. The wisp of red creates 'incident', ensuring content, so that it is more than just a graphic composition.

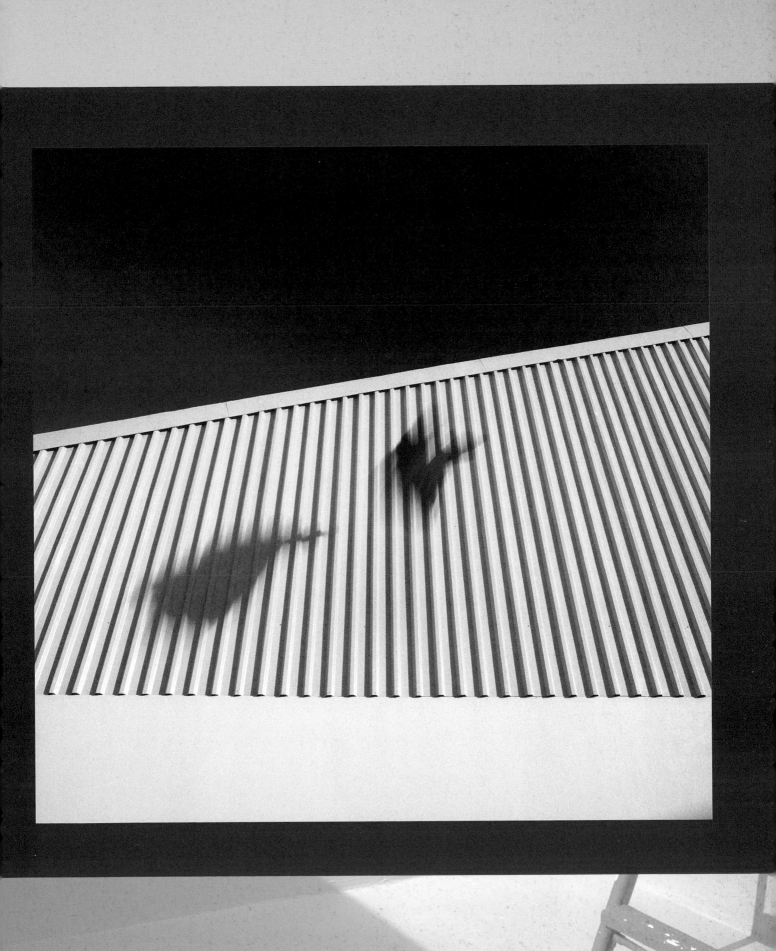

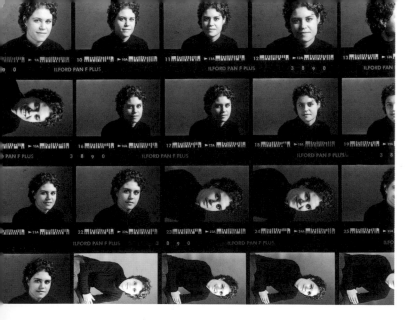

PROCESSING & PRINTING

There is nothing more thrilling than seeing your photograph appear like magic on the surface of the paper the first time you make a print. Working in the darkroom also teaches you early on how important good negative exposure is. After you have spent a whole day trying to print one bad negative, you will understand fully.

Whether you have a permanent darkroom or have to set it up in the kitchen or bathroom each time, the following aspects are important:

- it must be possible to make the room lighttight
- the room must have ventilation
- water and plumbing are needed close by
- photographic chemicals will stain and are corrosive – investigate how the chemicals will affect the work surfaces, floors, tap fittings, etc.
- if cost is a consideration, then keep in mind that a second-hand enlarger with a good lens is better than a new enlarger with a mediocre one.

Basic darkroom layout

A darkroom is divided into a dry area and a wet area, and allows for a good workflow between them.

The dry bench consists of the enlarger, photographic paper, multigrade filters, contact printer, easel and film. The wet bench carries the trays of chemicals that process and wash the prints. These two areas should be kept well separate: wet fingers can ruin negatives or printing paper, and for safety reasons electricity and water should be kept apart.

It is not necessary to paint the whole darkroom black – only the areas behind the enlarger and around the entrance door or light trap. If you are adapting a space, you can tape a piece of black card or PVC to the wall behind the enlarger. If there is no air conditioner or extraction unit in the room, you will need to take a break every half-hour to breathe some fresh air and to allow fresh air into the room.

Basic darkroom equipment

Dry bench

- Enlarger with lens
- Enlarger timer
- Easel
- Contact printer
- Focus finder (optional)
- Blower brush
- Printing filter kit
- Photographic paper
- Scissors or small guillotine
- 2 x A4 size card

Wet bench

- Set of trays
- Tongs
- Wash tray and hoses
- Clock
- 3 x measuring beaker
- Film and paper process chemicals
- A darkroom requires both a safelight and a white light source. Darkroom bulbs which can be plugged into an existing socket are available from most photographic stores. You will need at least two safelights – one above

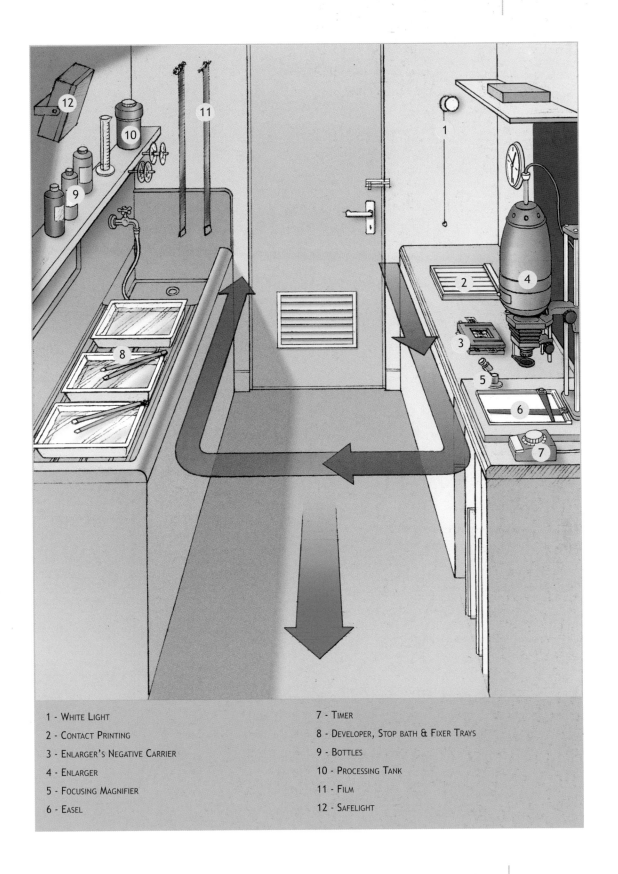

1 - White Light

2 - Contact Printing

3 - Enlarger's Negative Carrier

4 - Enlarger

5 - Focusing Magnifier

6 - Easel

7 - Timer

8 - Developer, Stop bath & Fixer Trays

9 - Bottles

10 - Processing Tank

11 - Film

12 - Safelight

TOP: A schematic diagram showing the workflow and basic layout of a photographic darkroom.

the dry bench and another near the wet bench. The white light will enable you to evaluate your tests.

When purchasing process trays, get three different colours and code them according to the chemicals they will contain – developer, stop bath and fix. The same applies to the tongs and beakers. Contamination can adversely affect your results and using dedicated containers will prevent this. You can further ensure trouble-free results by washing everything thoroughly after use.

Black-and-white negative processing

Processing equipment requirements

- Developing tank and reels
- Thermometer
- Scissors
- 3 x one-litre (two-pint) measuring jug
- Negative developer
- Stop bath
- Fix
- Hypo clearing agent
- Wetting agent
- Darkroom clock/timer
- Film wiper or chamois leather

Loading film

Exposed film needs to be loaded onto the processing reel in complete darkness, without even a safelight. Lay out the tank, lids, reels, reel rod and scissors on the work top in front of you. Make sure that you know where each item lies, so that you will be able to find them in the dark. Remove the exposed film cassette from your camera. If the leader tongue is still visible, cut it off so that the end of the film is straight (see opposite).

Make sure that the reel is completely dry, especially if you are using a plastic one. A wet reel is difficult to load. Ensure that the two small flag indicators are opposite one another.

Close the door, switch off the light and ensure that you are working in complete darkness. If you have already cut off the film tongue you will be able to load the reel immediately. However, if the film is wound back into the cassette you will need to break it open to get to the film. Run your fingers along the edges of the film until you feel the beginning of the tongue leader (a) and then cut it off, leaving a straight edge (b). Guide the film under the two small flag indicators (c) and over the ball bearings.

Gently pull the film onto the reel. Once you have threaded a length of about 2.5cm (I in), it is safe to begin

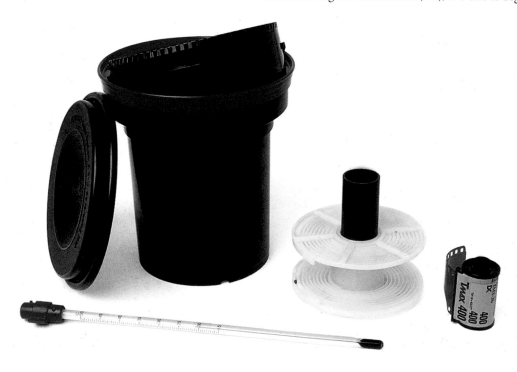

ABOVE: The basic requirements for the processing of black-and-white film: thermometer, developing tank and reel.

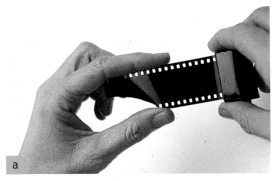

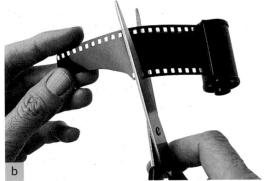

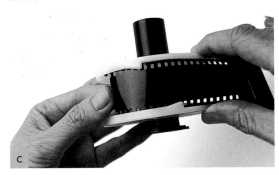

rotating the reel slowly (thumbs on flags) and you will feel the film slip past your fingers (d). Continue rotating until the cassette end prevents further winding. Cut off the cassette. Rotate the reel to load the end piece. It is important to keep your thumbs on the flags throughout the loading process. This will prevent the film from slipping off the edge of the reel. Practise with an old film until you get it right each time in the dark.

Insert the reel rod through the centre of the reel and put it in the tank (e), ensuring that the flattened disc end fits into the slot at the bottom of the tank. Put on the tank's lid. With the lid securely closed, the film is shielded from light and you can turn on the light.

It is possible to load film into developing tanks inside a photographer's lightproof changing bag, in which case the room light can be left on.

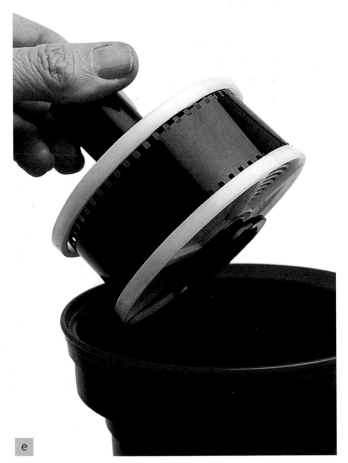

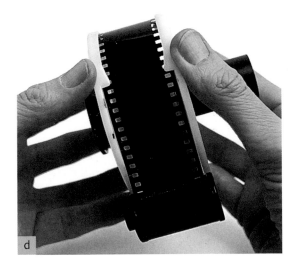

ABOVE: If unable to cut the film leader tongue beforehand, you'll have to feel in the dark along the edges (a) for the right place to cut (b). Pull the film onto the reel under the pair of flags and over the ball bearings (c). Place thumbs on the flags (d) and rotate the wheel. Load reel (e) and close lid.

Processing bench (wet bench)

1. Fill a measuring jug with 1 litre (2pt) of water. Make sure that the water's temperature is exactly 20°C (68°F). If it is too hot, add ice and if it is too cold, add hot water. It is very important to process film at the manufacturer's recommended temperature.

2. In a second jug measure out the required amount of developer. To this, add the indicated amount of water (at the correct temperature) for the number of films you are processing. Pour the remaining 20°C (68°F) water into the developing tank to prewet your film. The reasons for prewetting film are:
 - it guarantees that your film is at the correct developing temperature
 - it ensures that the whole film will receive the chemical solution at the same time when it is poured into the tank
 - any dust on the film will be washed off

3. Close the upper lid of the tank.

4. Invert the tank twice, tap it gently on the wet bench (this is known as agitation) and leave to stand for 30–45 seconds.

5. Remove the upper lid and pour away the water.

6. Set the darkroom clock to the developing time, according to the chart provided with the chemical packaging. Pour the developer into the tank and begin timing the process.

7. For the first 30 seconds of the processing time, agitate the tank continuously. Thereafter invert the tank and tap it on the bench once every 30 seconds for the rest of the developing time.

8. In-between the agitation slots, mix the next chemical for the process, which is the stop bath.

9. At the end of the developing time, remove the tank's upper lid, pour the solution down the sink and pour in the stop bath solution. Replace the lid, agitate the tank for about 10 seconds and leave to stand.

10. Pour the stop bath solution down the sink after 30 seconds, which includes the 10 seconds of agitation, and add the last solution – the fixing bath.
 Fixing time is 2–4 minutes, depending on the brand of chemical you are using.
 The agitation rate for fixing is: continuously for the first 10 seconds, thereafter one inversion and one tap of the tank every minute.

11. Return fix to the storage bottle and wash the film in running water for 10 minutes. It is important to remove all residue of chemical from the film. Some tank manu-

ABOVE: Inversion technique used when processing black-and-white film.

facturers supply a specialized tap fitting that fits into the lid of the tank to ensure that washing is thorough.

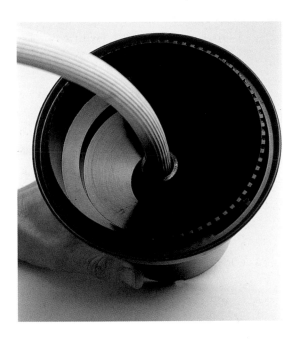

There is a chemical solution, called a hypo clearing agent, which aids the washing process and saves up to 50 per cent of wash time. It is not essential, but useful if available.

12. At the conclusion of the washing cycle, add a drop of wetting agent to the developing tank. Swirl the reel around in the tank, making sure that the wetting agent is well mixed with the water. Remove the reel from the tank and the film from the reel. Take great care of your film at this point, because the wet emulsion is soft and easily scratched.

13. Carefully wipe your film down with a wet, softened chamois leather cloth or special film wipers.

14. Hang the film up to dry, which takes 20–60 minutes depending on the ambient temperature and whether you have a negative drying cupboard. Resist the temptation to examine the negatives while they are damp and still vulnerable to dust and damage.

15. Once they are dry, cut them into strips of six and place them in negative sleeves immediately.

They can now be viewed safely and assessed for the next step – which is contact printing.

Photographic papers

Printing papers are available in two types, namely resin-coated (RC) and fibre-based papers (FB). Both types come in different printing surfaces such as glossy, matt, semimatt, and so on.

Use RC papers to start with. They are not only marginally cheaper, but also quicker to work with and less susceptible to chemical staining. All the times quoted here are for RC paper.

The choice of surface is up to you, but usually it is easier to learn to print on a glossy surface.

Fibre-based papers produce prints of a rich tonal quality and for that reason they are used in the printing of exhibition-quality photographs.

ABOVE LEFT: A special wash hose inserted into the top of the developing tank ensures effective washing by forcing the water down the tank centre.

ABOVE RIGHT: Clasp negatives by their edges and slide carefully into negative sleeves.

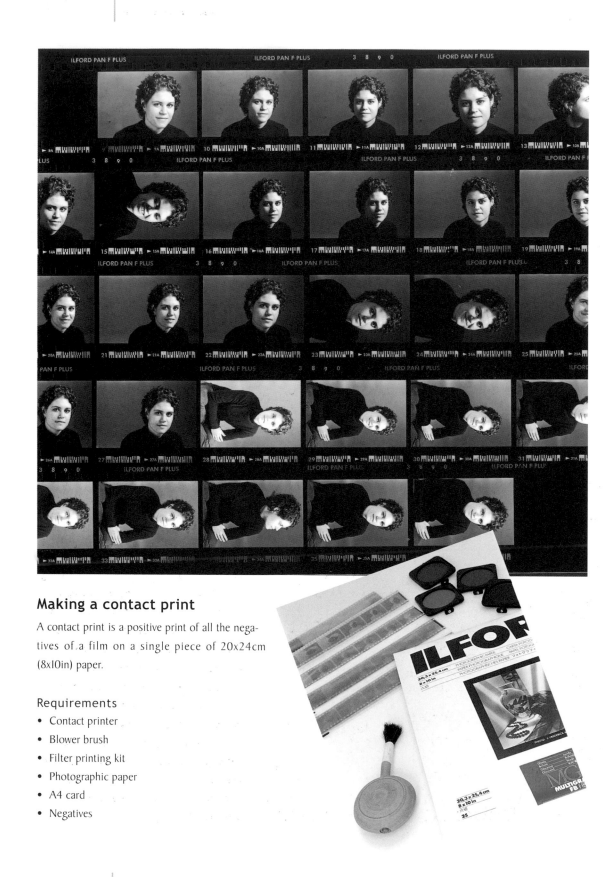

Making a contact print

A contact print is a positive print of all the negatives of a film on a single piece of 20x24cm (8x10in) paper.

Requirements

- Contact printer
- Blower brush
- Filter printing kit
- Photographic paper
- A4 card
- Negatives

TOP: A contact print, also known as a proof sheet.

ABOVE: Items required to make a contact print: negatives, variable contrast paper, printing filters and a blower brush.

Procedure

- View negatives on the light box, but keep them in their sleeves because the acetate film causes static, which in turn causes dust to stick to the film.
- Select a strip of negatives that represents the film in terms of densities.
- Filter selection depends on densities (see table below).

NEGATIVE TYPE	FILTER SELECTION
Normal exposure – good overall density	2 or 2½
Overexposed or dense negatives	00–1½*
Underexposed or thin negatives	3–5*

* choice will depend on degree of over- or underexposure

- Before you begin, make sure that the glass of the contact printer is clean and free of dust and fingerprints.
- Time, rather than aperture setting, is generally changed when adjusting for the required exposure. However, if the negative is badly overexposed or underexposed, change the lens aperture to avoid impractically long or short exposure times.

The adjacent table is a filter selection guide using the Ilford multigrade printing system. This system consists of 10 filters ranging from 00 through to 5, but counting up in half-step increments: i.e. 00, 0, ½, 1, 1½, 2, 2½, 3, 3½, 4, 4½, 5. These filters are used to adjust the contrast of the print, obviating the need for different grades of paper from low-contrast to high-contrast. Instead, using variable-contrast paper, you can alter the contrast with the use of different filters on the enlarger head.

Graded papers

When printing with graded papers, the use of filters is not necessary. The paper itself adds or suppresses contrast. The grades range from 0 to 5. Grade 2 is the paper to use for well-exposed negatives with good density. Negatives that are underexposed and thin will require the use of grades 3 to 5, depending on the degree of underexposure. Negatives that are dense can be printed using 0 or 1 grade paper. Like multigrade (MG) or variable contrast (VC) papers, graded papers are available in various surface options, such as gloss, semimatt or matt, as well as in RC or fibre base (see p111). When using graded papers, your negative assessment is the same as for multigrade paper. You will select the paper grade to suit your negative. In testing, processing and test strip assessment, you will also follow the same procedures as those used in multigrade printing.

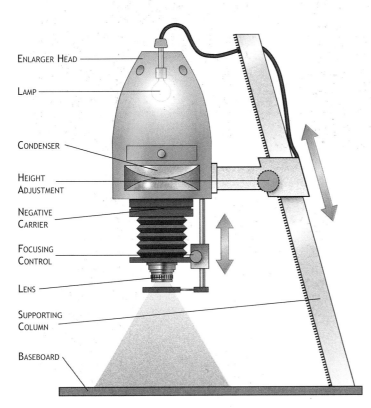

ENLARGER HEAD

LAMP

CONDENSER

HEIGHT ADJUSTMENT

NEGATIVE CARRIER

FOCUSING CONTROL

LENS

SUPPORTING COLUMN

BASEBOARD

ABOVE LEFT: The diagram illustrates the basic enlarger anatomy.

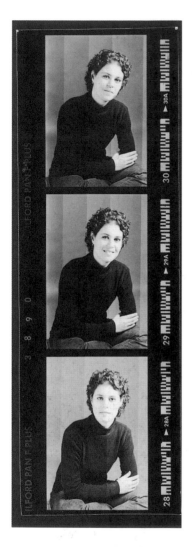

Making test strips

It is necessary to make test strips of a representative strip of negatives before making a full contact print. This will help you establish the minimum printing time (MPT) and the best filter to use when you make a contact print of the whole film. Once you've made and evaluated the test strips, follow the same procedure to make a full contact print, eliminating the steps involving test printing only.

At the dry bench (under safelight conditions)

- Place contact printer on the baseboard of the enlarger.
- Switch on the enlarger via the linked timer.
- Turn the lens so that maximum light is projected through it.
- Ensure that this projected light covers the entire contact printer. If not, move the head of the enlarger up or down until it does.
- Stop the lens down two stops. Less light will allow a longer exposure time, allowing for bigger increments in exposure time on the test strip, which will be more easily distinguishable. Switch off the timer to switch off the light.
- Load the selected filter into the tray in the enlarger head.
- Remove a single sheet of photographic paper from its box and cut it (on the vertical) into five strips. Each length will be wider than a 35mm negative. Place four of these back in the lighttight box for use in later tests.
- Open the glass lid of the contact printer and place the fifth test strip, emulsion side up, on its base. (If you are unsure which is the correct side, place the strip between your lips – the side that sticks to your lip is the emulsion side.)

- Clean the selected negative strip with the blower brush. Place it on top of the paper test strip, emulsion side down and close the glass. (The emulsion side has the matt finish, toward which the film curls. However, if you can read the name of the film on the negative, you've got it right.)
- Take the piece of A4 card and cover the test strip, leaving a quarter section along the top of the length of the strip visible as your first section.
- Set the timer and expose this section for 3 seconds. Uncover the next quarter and expose again for 3 seconds. Do this until the whole strip has been uncovered. The first section will have received a total of 12 seconds exposure, with each successive section getting three seconds less.
- Set the timer for 10 seconds and expose the whole strip. The first quarter section will now have been exposed for the maximum time of 22 seconds.
- Remove the test strip from the contact printer and go to the wet bench.

At the wet bench

The chemicals used for printmaking are the same three basics used for negatives, namely developer, stop bath and fixer. You can use the same stock solutions for the stop bath and fixer – only the dilutions are different. However, the developer used for printmaking is completely different to that used for negatives. Check what brands are available in your area and experiment with the different types on different papers until you get a combination you like. The trays should be laid out in their colour-coded order with matching tongs. It is advisable to use tongs instead of your fingers because sensitive skin may develop an allergic reaction to the chemicals.

If the temperature in your darkroom is 18–24°C (64–75°F) and stable, it will not be necessary to measure the temperature of the chemicals and the times given here will be accurate enough.

However, if the temperature is above or below this range, you will have to increase or decrease the developing time for best results.

ABOVE: The test strip was made using the Ilford Multigrade Printing system. Filter 3 was selected. The exposure times range from 13 to 22 seconds.

Processing

1. Place the test strip in the developer and agitate the tray throughout the developing time. This agitation involves a gentle rocking of the tray, with your fingers below the lip – just sufficient movement to cause a small wave of fresh chemical solution to wash over the surface of the print each time.

Vigorous rocking will cause the print to be overdeveloped. The developing time is 2 minutes.

2. Remove the strip with tongs and place it in the stop bath for 15 seconds.

3. Place the strip into the fixer for 30 seconds. Remove and wash for one minute.

4. Using a small carry tray, take the test strip to the white light source for evaluation. If you do not use a carry tray the darkroom floor will get wet and slippery. Before switching on the white light, ensure that all photographic paper has been stored safely.

Test strip evaluation

The two most important factors that govern test strip evaluation are contrast and exposure time.

The strip will show the exposure range from 13 through to 22 seconds at three-second intervals. The small pictures will give an indication of contrast. Contrast will determine how much of what is on the negative will be seen on the test strip. If the contrast is too high, very little detail will be visible – the highlights will be white and the shadow areas black.

Reducing the contrast is easy when using the multigrade printing system – it's a case of changing a filter.

If your original filter choice was 2½, you would lower it to 2 or 1½ to overcome the excessive contrast. If the strip lacked contrast, you would move up the scale to a higher filter such as 3 or 3½.

FILTER	EFFECT
00, ½, 1, 1½	Softer effect
3, 3½, 4, 4½, 5	Contrasty effect

At first, this is the hardest part of working alone in the darkroom. An experienced printer would be able to help you with initial choice of filter and subsequent changes as necessary. If you are alone, testing will take longer, and you will have to do more of them.

Only once you have sorted out the contrast, does it become necessary to worry about the exposure time. The filters do not only have an effect on contrast, but will, because of their factor, influence the exposure time as well.

Examine the area between two negatives – where it is clear on the negative it will print black on paper. However, because the test strip contains a series of exposures (ranging from 13 to 22 seconds) these increments will render clear film as a progressive series from muddy grey to dark grey through to black.

ABOVE LEFT: The method of tray agitation when processing prints.

TOP RIGHT: A test strip made with a 1½ filter.

ABOVE RIGHT: A test strip made with a 0 filter. The final contact print was made with a 1½ filter.

The section where the clear film first prints black represents Minimum Printing Time (MPT) for that film. This will differ from one film to another because each film's clear area is different.

Return to the enlarger, set the timer to the MPT and make another test. After processing assess this test, making sure that you are satisfied with the rendition of the contrast and that the clear area between the negatives is printing black. If all is correct, lay down a full sheet of photographic paper, and lay down the whole film. Make sure that the negatives are in the right order and the correct way up – name of film on top, negative numbers below.

Expose the paper, setting the timer to the MPT.

Process the paper, using the same method as for the tests. However, because the contact print will not be discarded, stop bath time increases to 30 seconds and the fixer time to 2 minutes, which is standard with the use of Ilford Multigrade chemicals.

Wash the print for 5 minutes in running water, or treat it with a combination of hypo clear and washing.

Tests are rinsed, rather than washed, because they will be discarded after use. Full-size enlargements, however, must be washed for 5 minutes in a tray of running water. Special washing hoses are available. Rinse the prints in a tray of water with a cap of wetting agent to prevent water drops from forming on the print. Ensure that prints are separated while drying.

Tabulation of times for tests and full-size prints		
	TEST STRIP	FULL PRINT
DEVELOPER	2 minutes – continuous agitation	2 minutes – continuous agitation
STOP BATH	15 seconds	30 seconds
FIX	30 seconds	2 minutes

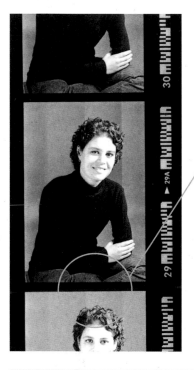

This test shows a series of exposures with increments of 3 seconds added to an overall exposure time of 10 seconds. The clear film between shots has printed in a range of tones from dark grey to black. The point where true black first appears is the Minimum Printing Time.

Reasons for contact printing

- It enables the photographer to see the whole film at a glance, which makes selection easier.
- It acts as a printing guide. If correctly produced, a contact print should indicate, in miniature form, the final result of the print. Never make a print without consulting the contact print, and work with it all the time.
- It can be used for reference – it is easier to look at a positive image than a negative.

ABOVE: The test strip illustrates how to calculate the Minimum Printing Time (MPT) for a contact print.

Making enlargements

Guidelines for printmaking

- Always consult the contact print. A well-produced contact print shows the potential of every negative.
- Get to know how each multigrade filter affects contrast, exposure time, and so on.
- Check that the enlarger head is level and that the lens is dust free.
- Initially, stick to the same combination of film, paper, and chemicals. Once you are confident that you understand the process, experiment with other product combinations.
- Do not take short cuts or guess – it will cost you time and money.
- If you are unsure, make more tests, however tedious it may seem. Test strips can save you a lot of paper and money.
- Do not alter the set processing times. Get into the routine.
- Read up on Ansel Adams' Zone System to help you learn to see in black and white.
- Keep a data sheet with all the printing information for each proof sheet and enlargement, for reprinting.

Procedure

1. Remove the selected negative from its sleeve and clean it with a blower brush. Place it in the negative carrier of the enlarger to show through the 'window' of the carrier. Never cut out the negative you want to print.
2. Set the size print you want to make on the easel.
3. Switch on the enlarger, open the aperture to its widest to supply maximum light for easier focusing, and check that the projected image fits the paper size set on the easel. If not, adjust the enlarger head until it does. Make it a rule to print the full negative format. Cropping increases the extent to which the negative has to be enlarged, thus reducing print quality in terms of sharpness. Do all your cropping in the camera.
4. When the image size is set and focused, stop down the lens – use the contact print data sheet information. Switch off the timer/enlarger head light.
5. Load the filter into the enlarger head. Do this last because it is difficult to focus with the filter in place.
6. The testing and processing procedure is exactly the same as when proof printing – and you must test, you

cannot use the same time as that used in the making of the contact print. This is due to two factors. (i) When contact printing, the negative is in contact with the paper, whereas now it is being projected onto it, and (ii) you probably have to move the enlarger head up or down to accommodate a change in size.

7. Place the test strip over as many different tonal areas as possible. Ensure that the test shows the effect of time increments on these areas.
8. Evaluate the test under white light, using the contact print as a guide.
9. Make at least three tests, before making the final print.
10. Negatives that look the same on the light box seldom are, therefore every negative must be individually tested.

TOP LEFT: Insert the negative into the window of the enlarger negative carrier.
TOP RIGHT: The blower brush ensures a dust-free print.
ABOVE: Set the arms of the easel to the required print size.

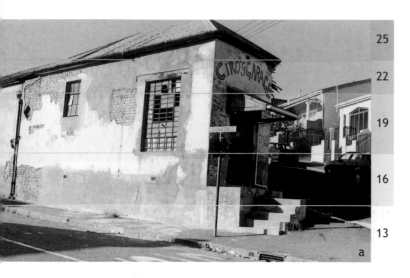

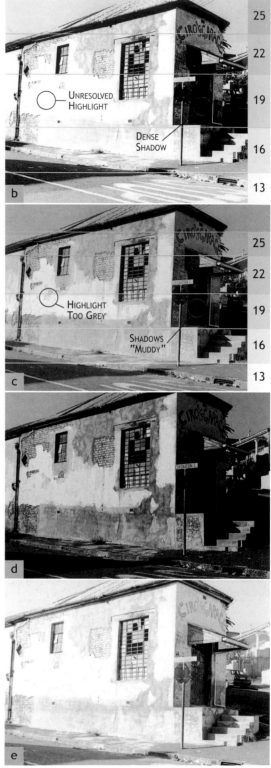

Test strip evaluation

Contrast and time are the important factors, but with enlargements, you have a larger area to work with and are therefore better able to control and manipulate.

When you placed your test, it was over as many different tonal areas as possible. Now, on the processed strip, examine the contrast and how it has affected these areas.

- If the contrast is too high, lower the filter value, for example from filter 2 to 1½.
- If the photograph is flat, i.e. mostly grey with little tonal variation between black and white, you'll need contrast. Raise the filter from 2 to 2½, for example.
- If the overall appearance of the test is too dark, it has been overexposed in the enlarger. Stop down the lens to decrease the intensity of the light.
- If the overall appearance is too light, it needs more light, so open up a stop.
- Once you are satisfied with the contrast, turn your attention to the exposure time. The timed exposure segments should give a stepped range from which to select. Ensure that the highlight areas have detail and are not just white. Similarly, the shadows should have detail and not be just black. When you are selecting time, be careful not to overexpose a photograph just to get highlight detail and thereby sacrificing detail in the shadows. It is possible to get detail in highlight and shadow areas at the same time, through the process of burning in.

ABOVE: (a) Filter 2, used here, was the right filter for this negative. (b) The test strip using the 3 filter was too contrasty and (c) using the 1½ filter was too soft. (d) The test with the 2 filter was overexposed in the enlarger (overprinted). (e) The test strip using the 2 filter was underexposed in the enlarger.

Burning in

Sometimes the overall quality of the print is good except for a lack of detail in the highlight areas. This often happens when you are photographing under contrasty light or areas of exposure extremes. Burning in will give these highlight areas more exposure than the rest of the print and show up the missing detail.

To determine the additional exposure time necessary:

- Ascertain the basic printing time by the usual strip testing method.
- Place another test strip across the image, including as much of the highlight area as possible. Expose this test to the basic exposure time that you have just calculated. On top of this test, but in the highlight areas only, expose a series of four 5-second segments. Process the paper and assess under white light.
- This test will reveal more highlight detail. Select the segment with the best tonal rendition. If the basic time was 22 seconds and the segment with good highlight detail is the 10-second segment, the highlight area must be given 10 more seconds of exposure time than the rest of the print.
- Take a piece of A4 card. Make a hole in the centre big enough for your forefinger to fit through.
- Expose the paper to the basic printing time.

- Cover the image with the card, holding it about 10cm (4in) above the paper, moving the hole over the area you wish to burn in.
- Set the timer to the burn-in time and switch on. During this time you need to move the card around the burn-in area, controlling the light and where it falls. If you don't keep the card moving, the hole will be visible on the print. Don't despair if you don't get it right first time; practise on test strips.

In conclusion

Great satisfaction can be derived from printing your own work. An experienced printer will be able to advise you on filters, papers, developers, lenses and so on, and, most importantly, how to evaluate test strips. Alternatively, find out if a college or school in your area offers evening classes in printmaking. Perhaps you can start a group of photography lovers who can share technical knowledge and critique each other's work. Not only is photography an international language, but it also seems to be an international favourite – you will never have to go far to find someone else who has an interest in or loves photography.

Enjoy your darkroom. Being a photographer is a constant learning experience. Never go anywhere without your camera – just keep seeing and making pictures, and enjoy it all.

ABOVE LEFT: A test print using calculated time from the filter 2 test strip. Notice that the highlight areas have unresolved detail.

ABOVE RIGHT: Burning-in on the wall, the white building in the background and on the road.

USEFUL INFO

Film manufacturers

Major film and camera manufacturers have websites listing local suppliers

AGFA: www.agfa.com

FUJI: www.fujifilm.com

ILFORD: www.ilford.com

KODAK: www.kodak.com

POLAROID: www.polaroid.com

Photographic publications and magazines

- Aperture – publishers of fine photography: www.aperture.org
- American Photo: www.hfmnewsstand.com
- B&W – black & white magazine for collectors of fine photography: www.bandwmag.com
- Petersens Photographic – reports on new equipment and photo techniques: www.photographic.com
- Photo Techniques USA – reports, data on new films and processes, darkroom technique and tests: www.phototechmag.com
- Practical Photography: www.emapmagazines.co.uk

Authors and photographers

Ask your local bookshop or librarian for books by these authors and photographers

Ansel Adams, Michael Brusselle, Michael Freeman, John Hedgecoe, Michael Langford, Beaumont Newhall, Edward Steichen, John Szarkowski, Minor White and Richard Zakia (co-authors), Eastman Kodak Publications

Photoschools and workshops

Find a night school or summer workshop near you. Listed below are institutions that have an excellent reputation in the industry and with government education departments

- International Center of Photography (ICP): www.icp.org
- Anderson Ranch Arts Center: www.museumstuff.com
- Brooks Institute: www.brooks.edu
- Maine Photographic Workshops: www.theworkshops.com
- New York Institute of Photography for distance learning: www.nyip.com
- The Nikon School (one-day workshops): www.nikonus.com
- Palm Beach Photography Center: www.workshop.org
- Photoworkshop.com (an interactive internet workshop): www.photoworkshop.com
- The Tuscany Workshops (photographer Joel Meyerowitz leads these intensive two-week colour workshops in Italy): www.tuscanyworkshops.com
- Most universities, polytechnics, design schools and colleges offer full and part-time courses – your local camera store will have information about these.

GLOSSARY

Aberration: The inability of a lens to render a perfectly sharp image across its entire field. The seven basic aberrations are: astigmatism, coma, chromatic aberration, spherical aberration, lateral chromatic aberration, curvilinear distortion and curvature of field. Compound lens design is one of the principle methods of reducing aberrations.

Actinic: The ability of light to cause a physical or chemical change within a substance. The actinic power of light during exposure causes the silver halide crystals in a photographic emulsion to change, forming a latent image.

Adams, Ansel: American conservation photographer and devisor of the Zone System – a method of exposure evaluation. See www.Anseladams.com

Aperture: The opening in a lens that controls the amount of light that passes onto the film. The degree of variability is indicated by f-stops.

ASA: American Standards Association – speed rating for photographic film. The rating is based on an arithmetical progression using an average gradient system.

Burning in: Also known as printing in, it is a system used in photographic printmaking, giving extra exposure time to selected areas of the print, usually the highlight areas.

Bekker, Phil: Atlanta-based photographer. See: www.bekker.com

Borges, Phil: Conservation photographer dedicated to the documentation of the different cultures around the world. See www.philborges.com

Camera movements: Mechanical systems, most common in view cameras, which allow lens and film plane movement from the standard position. Refers to tilts and shifts, which allow changes to the shape and position of the image and to the distribution of sharpness within it.

Camera obscura: The original camera in its simplest form (see pinhole camera).

CCD: Charge Coupled Device. A sensor consisting of grids of light-sensitive picture elements (pixels) that generate an electrical charge proportional to the amount of light they receive. An analogue-to-digital converter changes the voltage into digital data (binary code).

CMOS: Complementary metal oxide semiconductor. Light-sensitive unit similar to CCD in construction and function.

Colour temperature: A numerical description of the colour of light. It is the temperature in degrees Kelvin (K) to which a perfect black body radiator (an object that does not reflect any light falling on it) would have to be heated to produce a given colour.

Converging verticals: The convergence of parallel lines through optical distortion, so that they appear non-parallel.

Decisive moment: This term is associated with the photographs of the 'father of photojournalism' Henri Cartier-Bresson, and it describes the nature of his work. His images capture a precise moment of truth in the lives of his subjects.
See: www.henricartierbresson

Density: The amount of metallic silver produced by exposure and development. It is measured in terms of the logarithm of opacity.

Depth of field: The distance between the nearest and furthermost point in a picture that appears acceptably sharp in an image. Achieved by the use of small aperture, e.g. f22, the effect can be exaggerated by the use of short focal-length lenses.

DIN: Film speed rating system used by the German standards organization (Deutsche Industrie Norm). It is based on a logarithmic scale, with increments in threes. Each stop of speed increased is indicated by an addition of three, e.g. 21 is twice as fast as 18.

Emulsion, photographic: Light-sensitive material which consists of a suspension of silver halides in gelatine, which is coated onto a base to produce photographic film or paper.

Exposure: The product of intensity of light and the time that light is allowed to act on a photographic emulsion. Controlled by aperture (intensity) and shutter speed (time).

Flare: Non-image-forming light scattered by the lens or reflected from the camera interior. Can lower image contrast.

Flash synchronization: The synchronous firing of a flash within the opening time of a camera shutter.

Focal length: The distance between the rear nodal point of the lens and the focal plane when the focus is set at infinity.

Frank Robert: Won a Guggenheim grant and crossed the United States photographing the American Dream. Published *The Americans*. See www.robertfrank.com

f-stop: Number indicating size of aperture.

Incidence: The arrival of a beam of light or particles at a surface.

Incident: Capturing an element of interest for an image with good communication value.

Incident light reading: Measurement of incident light falling on a subject.

Irradiation: Scattering of light in a photographic emulsion, causing loss of resolving power. Aggravated by overexposure.

ISO: International Standards Organisation. A film speed rating that incorporates ASA and DIN. This makes it possible for both systems to be understood worldwide.

JPEG: Joint Photographic Experts Group. A compressed image file used in image storage and transmission. Some loss of quality will be experienced.

Kelvin, degree: Unit of measure of colour temperature of light sources.

Latent image: The invisible image created by the exposure of a photographic emulsion to light. This image is rendered visible during the development process.

LCD: Liquid Crystal Display. A low-power display of control settings and on some digital cameras to preview or review images.

Linear distortion: The distortion of the horizontal or vertical lines within an image. These lines appear curved. This effect is usually caused by extreme short-focus lenses.

Maisel, Jay: New York-based commercial photographer. See www.jaymaisel.com

Memory Card: A removable card on which digital cameras store images.

Opacity: The light-stopping power of a medium expressed as a ratio of the incident light to the light transmitted.

Photons: Particles of light energy.

Pinhole camera: Container with a small hole, instead of a lens, letting light through to form an image. See camera obscura.

Refractive index: Numerical value that indicates the light-bending power of a medium such as glass.

Selective focus: The highlighting with focus of an area in an image. Created by the use of a wide aperture, e.g. f5.6 and enhanced by the use of long-focus lenses.

Sepia tone: Conversion from a black metallic silver image (print) to a brown tone.

Shutter: Mechanism that opens and shuts to admit light into a camera for a measured length of time. Most common today are the interlens-bladed and the focal-plane shutter.

Stopping down: Reducing the size of the lens aperture to reduce the amount of light passing through.

Stopping up: (Opening up.) Increasing the size of the lens aperture to increase the amount of light passing through.

TFT: Thin film transistor. A sharper display than LCD used as monitor screen.

TIFF: Tagged Image File Format. High quality image file.

Visual impression: The result created and associated with the use of specific camera technique, e.g. long-focus lenses – selective focus.

Webb, Alex: New York-based photographer. See www.alexwebb.com

Winogrand, Gary: American photographer famous for his off-beat vision of life in America in the early sixties.

Zone system: An exposure system created by the late Ansel Adams. See Adams, Ansel.

INDEX

CREDITS & ACKNOWLEDGEMENTS

Photography Credits

All photography by Sue Hillyard, with the exception of those supplied by the following photographers and/or agencies
(copyright rests with these individuals and/or their agencies): **p57** Image Bank, **p58** Erina van der Linde,
p70-71 Phil Borges, **p86-87** Magnum Photos/Alex Webb, **p104-105** Phil Bekker,
Cover Irvine Meyer, **p77, 91** Reprinted with permission of ELRU

Author's Acknowledgement

'To me photography is life, it has to deal with life'

These words of Robert Frank echo my own sentiments about my life's work.
In fact, photography dictates how one sees the world and records its history, its magnificence.
However, my life as a photographer and educator has not been solitary and it is with the publication
of this book that I would like to acknowledge those who have made a contribution of support over the years.
To my dad – a man whose third eye was his camera lens, who taught me the importance of
documentary photography and Mom, the wisdom of what was important to document.
To Colin, who instilled in me the determination to excel; and for his assistance and encouragement
through the writing and shooting of this book.
To Claudia, Anna, Gerry and Steven at New Holland – a formidable, dedicated and professional team – thank you.
To Mike, Michelle and the staff at Orms – the photo store made in heaven –
my gratitude for the excellent service and endless enthusiasm.
To Alex Webb, Phil Bekker and Phil Borges – photographers whose outstanding photographs are profiled in this book.
Your work is inspirational, I have no doubt that your images will inspire all those who read this book.
And to all photographers – continue to make photographs; your vision is unique and a gift to us all.